C000318913

Cool Hotels
New York

teNeues

Imprint

Editors: Martin Nicholas Kunz, Jake Townsend

Photos (location): Tom Crane Photography (Affinia Gardens), courtesy The Alex Hotel, Gregory Goode (The Bowery Hotel), courtesy The Bryant Park Hotel, courtesy Chambers a hotel, courtesy HKH Hotels (Hotel Giraffe, Library Hotel, Library Hotel backcover bottom), courtesy Hotel Gansevoort (Hotel Gansevoort, backcover on top), courtesy Hotel 57, courtesy The Lowell, courtesy The Franklin Hotel, Claudia Hehr (The Moderne, The Pod Hotel, The Pod Hotel backcover 2nd from top, Hotel on Rivington), Gavin Jackson (Four Seasons Hotel New York, The Maritime Hotel, Plaza Athénée, Hotel QT, The Mercer, The Mercer backcover 4th from top), Peter Page (Dream, Restaurant Amalia), Martin Nicholas Kunz (Dream, Night, Time), Roy Wright (Inn at Irving Place), courtesy Mandarin Oriental Hotels & Resorts (Mandarin Oriental, New York), courtesy Hotel on Rivington, courtesy Rosewood Hotels & Resorts (The Carlyle, backcover 3rd from top), courtesy Hotel Roger Williams, courtesy Sixty Thompson, Roland Bauer, Martin Nicholas Kunz (Sixty Thompson), courtesy Starwood Hotels & Resorts (The Westin New York at Times Square, W New York – Times Square), courtesy Tribeca Grand
Cover: Courtesy Mandarin Oriental Hotels & Resorts (Mandarin Oriental, New York)

Introduction: Jake Townsend

Layout & Pre-press, Imaging: Jeremy Ellington, Jan Hausberg

Translations: Alphagriese Fachübersetzungen, Dusseldorf

Produced by fusion publishing GmbH, Stuttgart . Los Angeles www.fusion-publishing.com

Price orientation: $ < 200 $, $$ 201–350 $, $$$ 351–550 $, $$$$ > 551 $

Published by teNeues Publishing Group

teNeues Verlag GmbH + Co. KG
Am Selder 37
47906 Kempen, Germany
Tel.: 0049-(0)2152-916-0
Fax: 0049-(0)2152-916-111
E-mail: books@teneues.de

teNeues Publishing Company
16 West 22nd Street
New York, NY 10010, USA
Tel.: 001-212-627-9090
Fax: 001-212-627-9511

teNeues Publishing UK Ltd.
P.O. Box 402
West Byfleet, KT14 7ZF
Great Britain
Tel.: 0044-1932-403509
Fax: 0044-1932-403514

teNeues France S.A.R.L.
93, rue Bannier
45000 Orléans, France
Tel.: 0033-2-38541071
Fax: 0033-2-38625340

Press department: arehn@teneues.de
Tel.: 0049-(0)2152-916-202

www.teneues.com

ISBN: 978-3-8327-9193-0

Bibliographic information published by Die Deutsche Bibliothek.
Die Deutsche Bibliothek lists this publication in the Deutsche Nationalbibliografie; detailed bibliographic data is available in the Internet at http://dnb.ddb.de.

Contents

Page

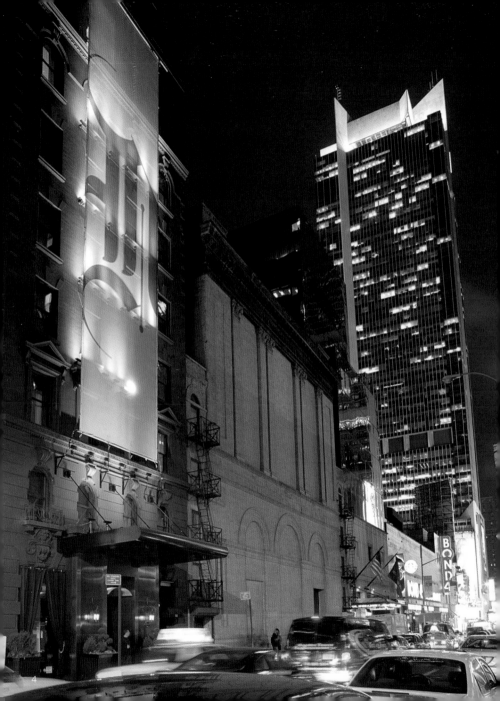

Introduction

New York City is the world's capital of cool. The world's most influential nightclubs, museums, and of course hotels are often found in the city that never sleeps. Though New York has always been known for its grand, ultra high-end hotels, there are incredibly cool hotels that many people still don't know about. From the *Four Seasons New York*'s 3,000 sq ft penthouse with its semi-precious stone accents and butler service, to *The Pod Hotel*'s one-room flats with bunk beds, to cozy boutique hotels like *the Library Hotel*, with its hand-picked selection of reading material in every room, the city has great choices for every budget and aesthetic.

New York's boutique hotels feel more like homes away from home, and staff feel more like family. If New York's hotels in the 1990's were characterized by lobbies that felt more like nightclubs, and service that was rude at best, the 21st century is all about relaxed elegance, great service and an atmosphere that caters to, rather than repels, guests. Small, chic spaces, intimate lounges and full service staff have replaced the snobbery of the past. Guests want to relax with friends on rooftop terraces at places like *Hotel Giraffe* or *Hotel Gansevoort* or work wirelessly from their suites as you can at *The Maritime Hotel* and the *Chambers a hotel*, rather than drape themselves on uncomfortable furniture, while shouting for a refill of their cocktails. Even larger, established hotels like the *Four Seasons New York* and the *Mandarin Oriental, New York* have adopted this focus on intimacy, realizing that fostering long-term relationships with guests is more important than being flashy, noisy and indifferent.

The aesthetic variation of New York's coolest hotels allows guests to indulge their whims; whether it's one of the scented, color–coordinated rooms of the *Time* or the mysterious, gothic theme of the *Night* or the whimsical, fairly-tale like ambience of the *Dream*, these hotels are sure to satisfy even the most jaded of visitors. So what makes a cool hotel, cool? In New York, it's all about service, style and substance.

Jake Townsend

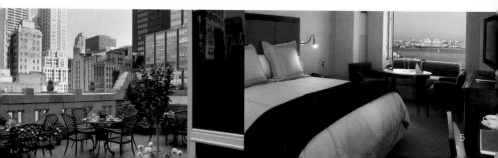

Einleitung

New York City ist die Hauptstadt des „coolen" Lebensstils. Hier, in der Stadt, die niemals schläft, findet man viele der maßgeblichen Nachtklubs, Museen und Hotels der Welt. Obwohl New York schon immer für seine eleganten und absoluten Top-Hotels bekannt war, gibt es immer noch unglaublich coole Hotels, die den Besuchern noch nicht bekannt sind. Angefangen mit dem *Four Seasons New York* und seinem 280 m² großen Penthouse veredelt mit Halbedelstein-Akzenten nebst Butler-Service über die Einzimmerwohnungen des *The Pod Hotels* mit Etagenbetten bis zu den gemütlichen Boutique-Hotels wie dem *Library Hotel*, in dem jedes Zimmer mit einer erlesenen Auswahl an Lektüre bestückt ist – die Stadt bietet eine große Hotelauswahl, passend für jedes Budget und jeden Geschmack.

New Yorks Boutique-Hotels bieten ihren Gästen fern der Heimat ein Stück Zuhause und das Personal vermittelt dem Gast das Gefühl von Familie. Auch wenn die New Yorker Hotels sich in den 90er-Jahren des vergangenen Jahrhunderts durch Empfangshallen auszeichneten, die eher den Eindruck von Nachtklubs mit bestenfalls unhöflichem Service vermittelten, so dreht sich im 21. Jahrhundert alles um entspannte Eleganz, großartigen Service und eine Atmosphäre, in der sich die Gäste wohlfühlen anstatt durch sie in die Flucht geschlagen zu werden. Kleine schicke Räumlichkeiten, Foyers mit privatem Flair und Spitzen-Personal haben den Snobismus der Vergangenheit abgelöst. Heute möchten Gäste mit Freunden auf Dachterrassen entspannen, wie z. B. im *Hotel Giraffe* oder im *Hotel Gansevoort*, möchten Besucher drahtlos von ihren Suiten und Zimmern aus arbeiten, wie im *The Maritime Hotel* oder im *Chambers a hotel*. Früher dagegen saß man auf unkomfortablen Möbeln und musste sich laut rufend um die Nachbestellung seiner Cocktails bemühen. Sogar die größeren und etablierten Hotels wie das *Four Seasons New York* und das *Mandarin Oriental, New York* haben ihre Bemühungen auf Gemütlichkeit ausgerichtet. Hier hat man ebenfalls erkannt, dass es wichtiger ist, eine langfristige Beziehung zu seinen Gästen zu pflegen als grell, laut und gleichgültig zu sein.

Durch die ästhetische Veränderung der coolsten New Yorker Hotels können Gäste heute ihren Launen frönen: in den duftenden und farblich harmonisch abgestimmten Zimmern des Hotels *Time*, durch die geheimnisvollen gotischen Themen des Hotels *Night* oder durch das märchenhafte Ambiente des Hotels *Dream* – all diese Hotels stellen auch den anspruchsvollsten Gast zufrieden. Und was macht ein cooles Hotel nun „cool"? In New York erreicht man es nur über Service, Stil und Inhalte.

Jake Townsend

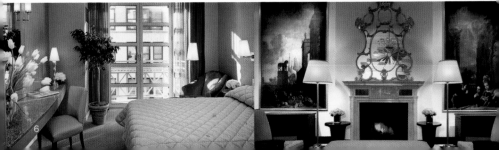

Introduction

New York City est la capitale mondiale de la vie « cool ». On trouve souvent les boîtes de nuit, les musées et bien sûr les hôtels les plus influents, dans la ville qui ne dort jamais. New York a toujours été connue pour ses hôtels grandioses ultra haut de gamme. Pourtant il existe des hôtels incroyablement cools qui ne sont toujours pas connus du public. Du *Four Seasons New York* penthouse de grand standing de 280 m² avec ses pierres fines et son service maître d'hôtel, aux studios une pièce du *Pod Hotel*, avec ses lits en étage aux confortables hôtels boutiques comme le *Library Hotel* avec sa collection d'ouvrages consultables en libre dans chaque chambre, New York City offre un large choix accessible à tous les budgets et une grande variété esthétique.

Les hôtels boutiques de New York sont davantage de véritables foyers et le personnel semble faire partie de la famille. Si les hôtels de New York dans les années 1990 étaient caractérisés par des halls qui ressemblaient davantage à des boîtes de nuit et possédaient le service le plus grossier, le XXIe siècle, par contre, possède une élégance décontractée, un excellent service et une atmosphère qui flatte plutôt la clientèle qu'il ne la rebute. Des petits espaces chics, des salons intimes et un personnel qui offre une multitude de services ont remplacé le snobisme du passé. Les clients veulent se relaxer avec des amis sur les toits en terrasses dans des endroits comme *Hotel Giraffe* ou *Hotel Gansevoort* ou bien travaillent sans fil dans leur suite au *Maritime Hotel* et au *Chambers a hotel* au lieu de s'allonger sur des meubles inconfortables tout en réclamant à grand cris un nouveau cocktail. Mêmes les hôtels les plus grands et les plus renommés comme le *Four Seasons New York* et le *Mandarin Oriental, New York* ont adopté cette vision de l'intimité, en réalisant que les relations à long terme, stimulantes envers la clientèle, sont plus importantes que le fait d'en imposer, d'être bruyant et indifférent.

La diversité esthétique des hôtels les plus cools de New York permet aux clients de satisfaire tous leurs caprices ; qu'il s'agisse de l'une des chambres coordonnées en couleur parfumées du *Time* ou du thème gothique et mystérieux du *Night* ou de l'ambiance fantaisiste, de conte de fées, du *Dream*, ces hôtels ont pour mission de satisfaire les visiteurs les plus exigeantes. Donc, quelles sont les qualités d'un hôtel cool ? A New York, tout est une question de service, de style et de qualité.

Jake Townsend

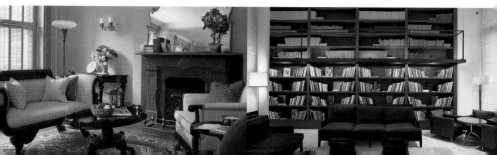

Introducción

La ciudad de Nueva York es la capital mundial del "cool". Los nightclubs, los museos y, desde luego, los hoteles más influyentes del mundo se encuentran a menudo en la ciudad que nunca duerme. Aunque Nueva York sea conocida desde siempre por sus hoteles de gran lujo y máximo prestigio, existen hoteles increíblemente cool que la mayoría de la gente desconoce. Desde el ático de 280 m² del *Four Seasons Hotel New York* con sus toques de piedras semipreciosas y su servicio de mayordomo, hasta los apartamentos de una pieza con literas del *Pod Hotel* y hasta acogedores boutique hotels como el *Library Hotel*, con su atenta selección de lecturas disponible en cada habitación, la ciudad propone abundantes opciones para todos los presupuestos y todos los gustos.

Los boutique hotels de Nueva York nos hacen sentir en nuestra casa aunque nos encontremos lejos, y su personal parece ser casi familia. Si las características de los hoteles de Nueva York en los años 90 eran salones que casi parecían nightclubs y servicio descortés o todavía peor, los temas del siglo 21 son relajada elegancia, excelente servicio y una atmósfera que complace a los clientes, en vez de rechazarlos. Espacios limitados y elegantes, salones íntimos y personal a completa disposición han sustituido el antiguo esnobismo. Los huéspedes ya desean relajarse con amigos en las terrazas de los techos, en sitios como el *Hotel Giraffe* o como el *Hotel Gansevoort*, o bien trabajar en conexión inalámbrica desde sus suites, como es posible hacer en *The Maritime Hotel* y en el *Chambers a hotel*, más bien que hacer de tapizado a muebles incómodos y tener que chillar para pedir otro cóctel. Incluso grandes casas establecidas como el *Four Seasons New York* y el *Mandarin Oriental, New York* han adoptado este nuevo enfoque a la intimidad, dándose cuenta de que fomentar relaciones duraderas con los huéspedes es más importante que aparecer llamativos, ruidosos e indiferentes.

Las variantes estéticas de los hoteles más cool de Nueva York permiten a los huéspedes gratificar cada capricho; tanto si nos encontramos en una de las habitaciones perfumadas y de colores coordinados del *Time*, como si estamos inmersos en la misteriosa atmósfera gótica del *Night* o en el extravagante escenario de cuentos de *Dream*, no cabe duda que estos hoteles sabrán satisfacer hasta el viajero más exigente. Entonces, qué es lo que convierte un hotel en un "cool hotel"? En Nueva York, nada más que servicio, estilo y sustancia.

Jake Townsend

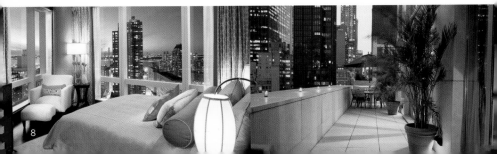

Introduzione

New York è la capitale mondiale del "cool". Nella città che non dorme mai si trovano spesso i night-club, i musei e (naturalmente) gli hotel più influenti al mondo. Anche se New York è da sempre nota per i suoi hotel di gran lusso e assoluto prestigio, vi si trovano alberghi incredibilmente cool che ancora non sono conosciuti alla maggioranza del pubblico. Dall'attico da 280 m² del *Four Seasons Hotel New York* con i suoi inserti in pietre semipreziose e il servizio di maggiordomo, agli appartamenti monolocale con cuccette a castello del *Pod Hotel*, ad accoglienti e intimi boutique hotel come il *Library Hotel*, con le sue letture scelte con cura e messe a disposizione in ogni camera, la città offre abbondanti possibilità di scelta per tutti i gusti e tutte le tasche.

I boutique hotels di New York danno più la sensazione di stare a casa propria anche se si è lontani, e il personale fa sentire l'ospite quasi come in famiglia. Se negli anni '90 gli hotel newyorkesi erano caratterizzati da saloni che davano l'impressione quasi di night-club, e servizio scortese quando andava bene, il secolo XXI è improntato su eleganza rilassata, servizio ottimale e un'atmosfera fatta per soddisfare il cliente, invece che per respingerlo. Spazi ridotti ed eleganti, salottini intimi e personale a completa disposizione hanno sostituito lo snobismo del passato. L'ospite preferisce rilassarsi con gli amici sul terrazzo sul tetto in posti come *l'Hotel Giraffe* o come *l'Hotel Gànsevoort*, o lavorare in connessione wireless dalla propria suite, come si può fare al *Maritime Hotel* o al *Chambers a hotel*, piuttosto che fare da tappezzeria a mobili scomodi, dovendo gridare per ottenere una nuova razione del proprio cocktail. Persino i grossi alberghi tradizionali come il *Four Seasons New York* e il *Mandarin Oriental, New York* hanno fatto propria questa nuova attenzione all'intimità, rendendosi conto che coltivare relazioni a lungo termine con gli ospiti è più importante che risultare appariscenti, chiassosi e indifferenti.

Le varianti estetiche degli hotel più cool di New York permettono all'ospite di assecondare i propri capricci; che ci troviamo in una delle camere profumate e dai colori coordinati del *Time* o immersi nella misteriosa atmosfera gotica del *Night*, o nella bizzarra e fiabesca ambientazione del *Dream*, non c'è dubbio che questi hotel soddisferanno anche il visitatore più esigente. E allora cos'è che contraddistingue un hotel cool da uno qualsiasi? A New York la parola d'ordine è di servizio, stile, sostanza.

Jake Townsend

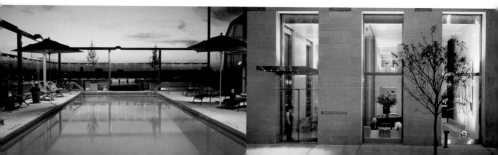

Affinia Gardens

215 East 64th Street
New York, NY 10021
Upper East Side
Phone: +1 212 355 1230
Fax: +1 212 758 7858
www.affinia.com

Cool Restaurants nearby:
Lever House Restaurant
Nobu Fifty Seven

Cool Shops nearby:
The Conran Shop

Price category: $$$
Rooms: 112 guest rooms and 97 suites
Facilities: The Serenity Lounge and complimentary tea bar, wellness spa and fitness center
Services: Grocery shopping, secretarial services, pets welcome
Located: Near Central Park
Subway: F Lexington Avenue – 63rd Street
Map: No. 1
Style: Contemporary design
What's special: Like an oasis in the middle of the most chaotic city in the world, Affinia Gardens is the only hotel in New York with a 24-hour relaxation lounge. The patio suites offer unparalleled outdoor luxury in the warmer months.

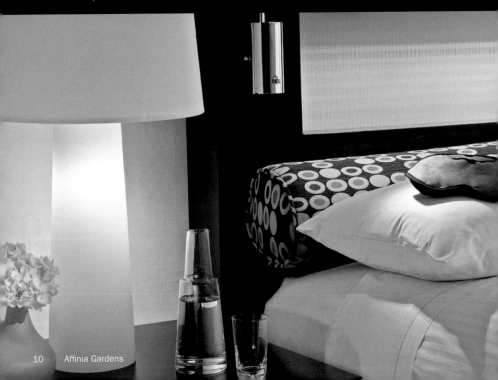

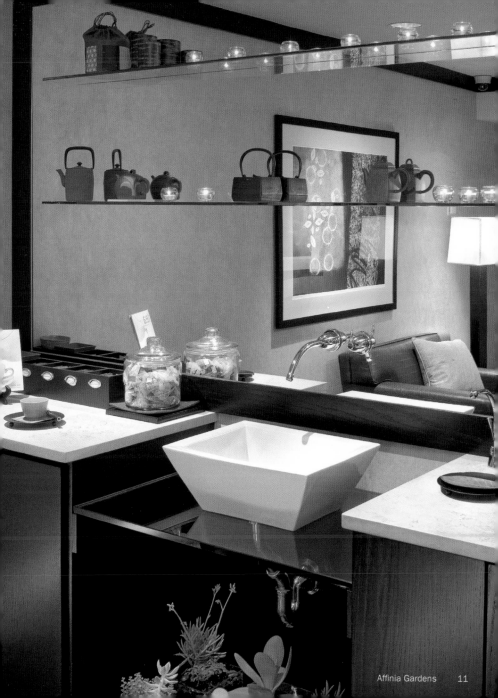

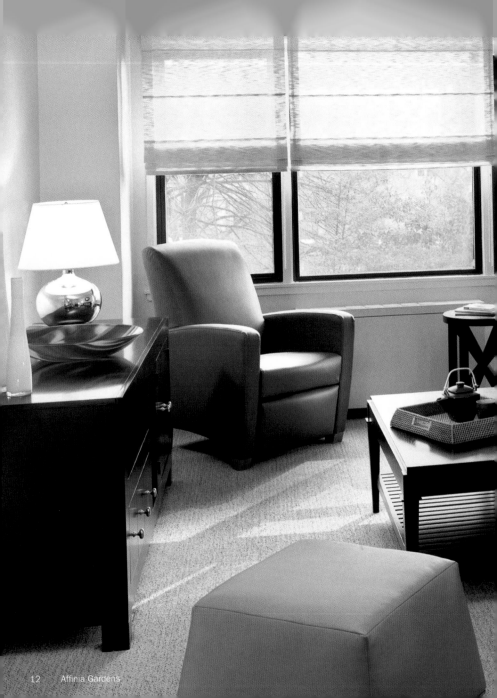

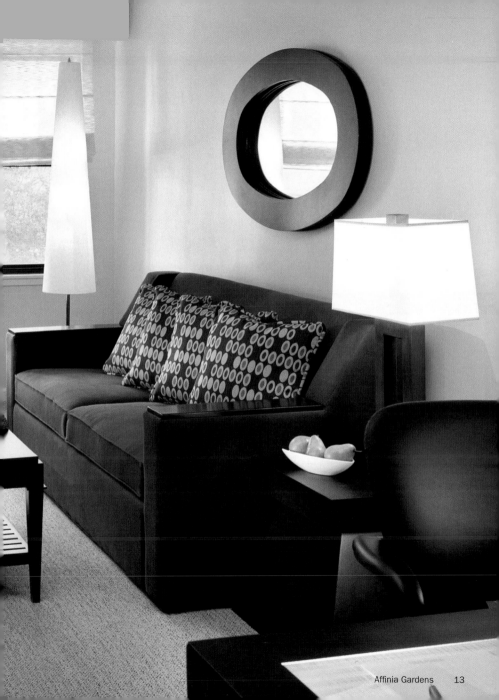

The Alex Hotel

205 East 45th Street
New York, NY 10017
Midtown
Phone: +1 212 867 5100
Fax: +1 212 867 7878
www.thealexhotel.com

Price category: $$$
Rooms: 203 rooms and suites
Facilities: Fitness center, business center
Services: Concierge service, WiFi, suites equipped with 30" LCD TV
Located: Between Grand Central Station and United Nations on 45th Street/3rd Avenue
Subway: 4, 5, 6 Grand Central Station – 42 Street
Map: No. 2
Style: Contemporary design
What's special: "Overnight or overtime": The Alex Hotel is the top choice for those guests looking for chic, modern long or short-term lodging. The limestone baths, snacks by Dean and Deluca and Poggenpohl kitchens, give the rooms an upscale apartment-like feel.

Cool Restaurants nearby:
Four Seasons Restaurant
Lever House Restaurant

Cool Shops nearby:
The Conran Shop

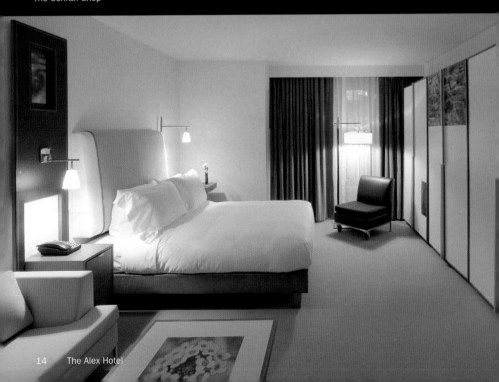

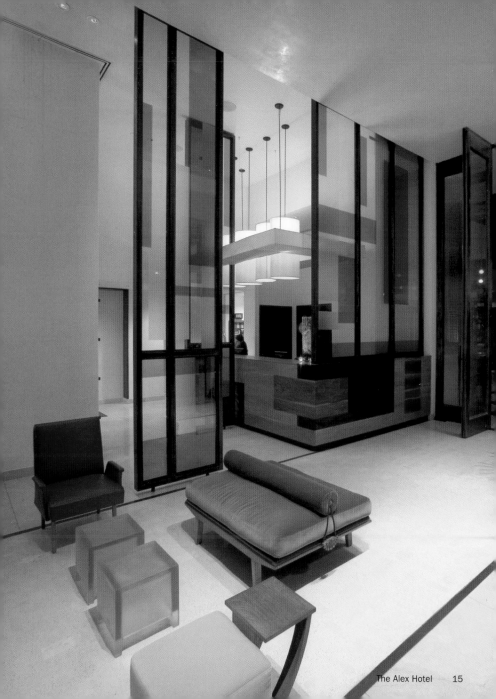

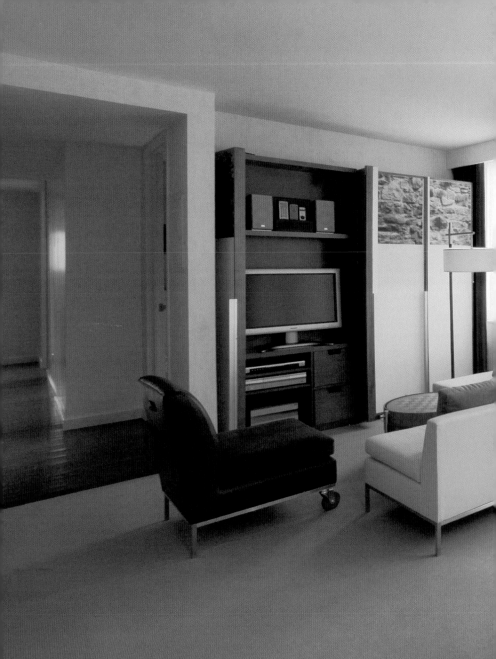

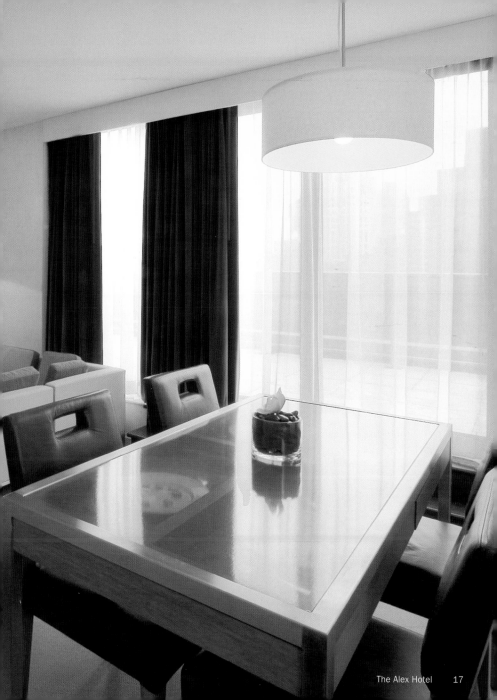

The Bowery Hotel

335 Bowery
New York, NY 10003
NoHo
Phone: +1 212 505 9100
www.theboweryhotel.com

Cool Restaurants nearby:
Indochine
Jack's Luxury Oyster Bar
Lure Fishbar

Cool Shops nearby:
A Détacher
BDDW
de Vera

Price category: $$$
Rooms: 135 rooms
Facilities: Restaurant Gemma, cocktail lounges, red-brick terraces, V.I.P. rooms on 2nd floor
Services: Flat screen TV, iPod-powered stereo, DVD player and free WiFi
Located: In NoHo between East Village and SoHo
Subway: 6 Bleecker Street; B, D, F, V Broadway-Lafayette Street
Map: No. 3
Style: Contemporary design
What's special: With a lobby straight out of early 20th century New York, and views that would make Leona Helmsley jealous, The Bowery Hotel is sure to become one of Downtown's hottest happenings.

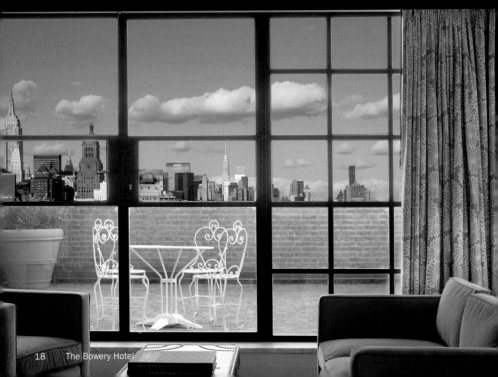

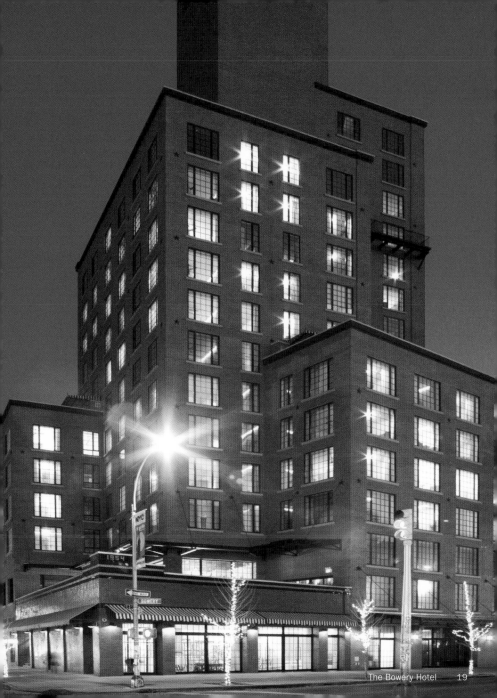

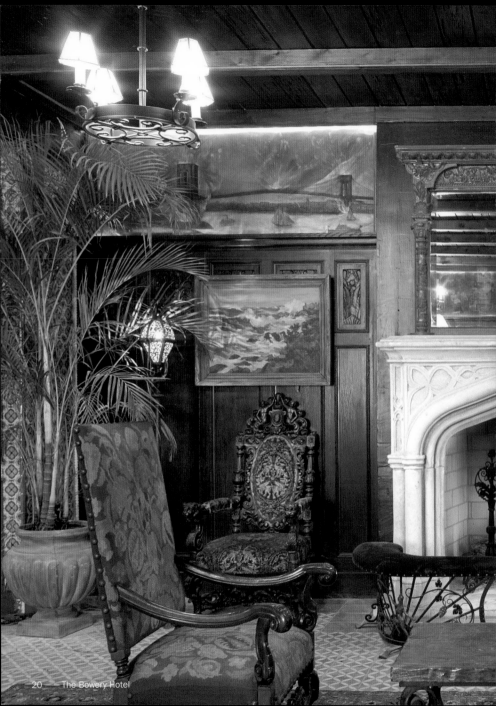

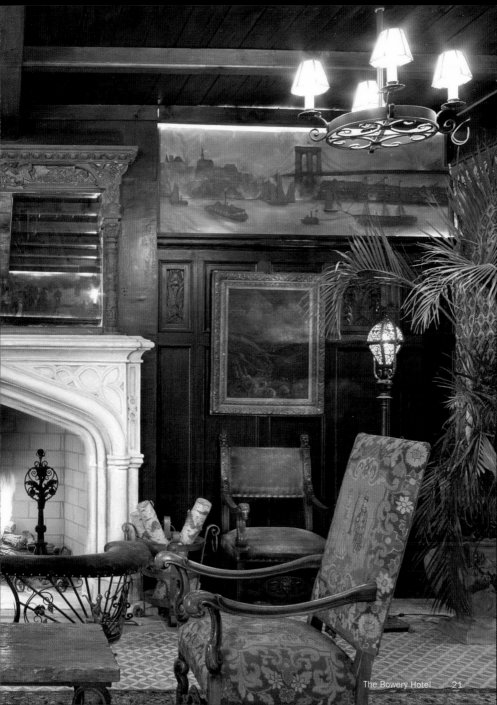

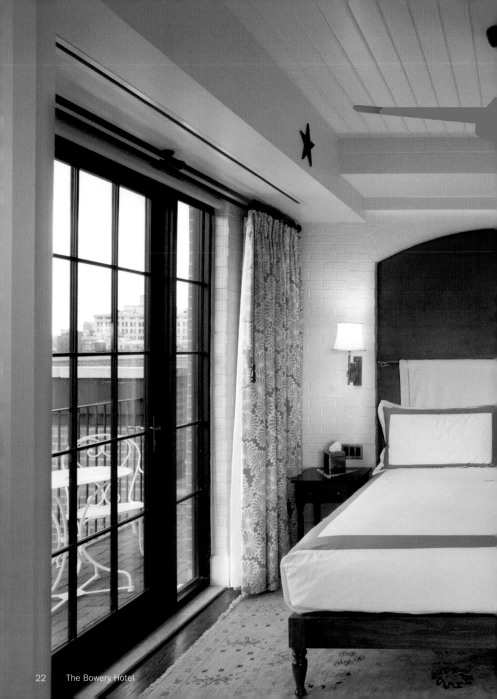

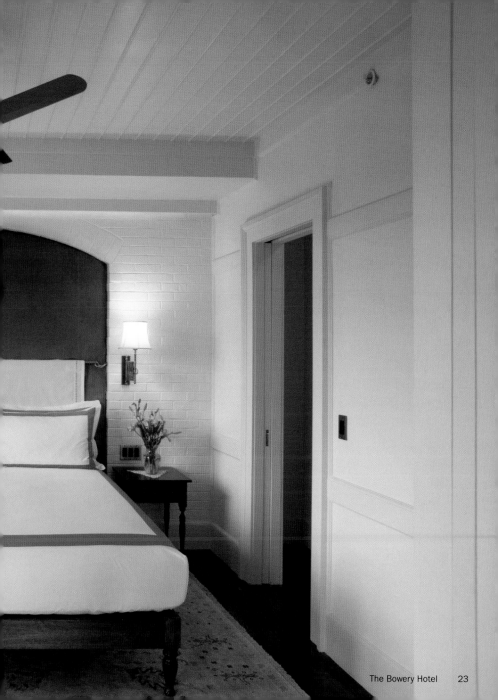

The Bryant Park Hotel

40 West 40th Street
New York, NY 10018
Midtown
Phone: +1 212 869 0100
www.bryantparkhotel.com

Price category: $$$$
Rooms: 129 rooms and suites
Facilities: Koi Restaurant, cellar bar, fitness center
Services: Bose CD players/radios come with docking stations. Complimentary fax sending/receiving
Located: Across Bryant Park, close to Times Square
Subway: A, C, E, N, Q, R, S, W, 1, 2, 3, 7 42nd Street – Times Square
Map: No. 4
Style: Contemporary design
What's special: A screening room, loft, private cinema, and one of the most attractive staffs in the city, work in concert to make The Bryant Park Hotel feel like a well-kept secret in the guise of a modern luxury hotel.

Cool Restaurants nearby:
Keens Steak House

Cool Shops nearby:
MoMa Design and Book Store

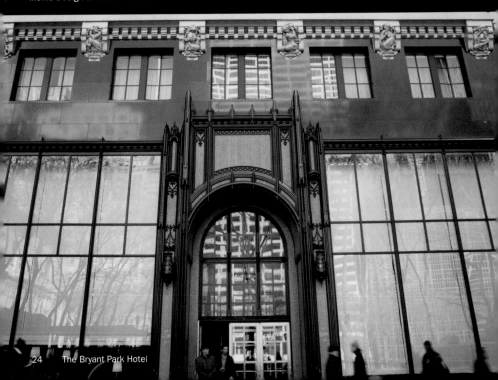

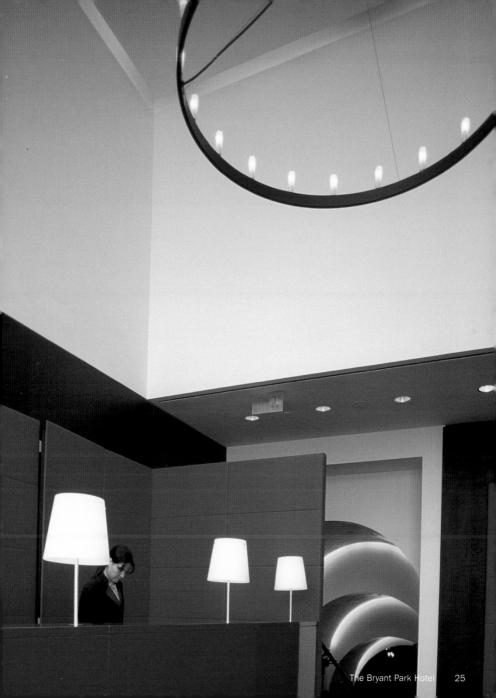

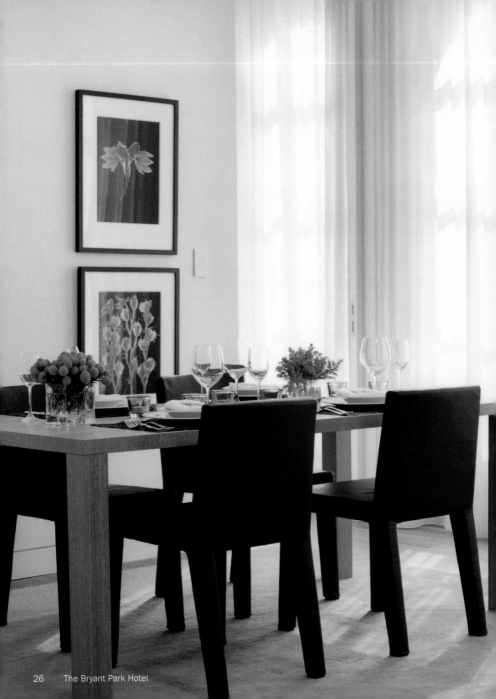

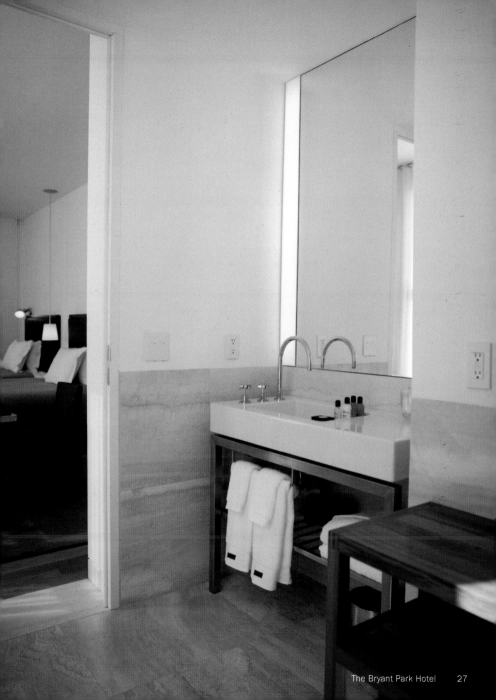

The Carlyle

35 East 76th Street
New York, NY 10021
Upper East Side
Phone: +1 212 744 1600
Fax: +1 212 717 4682
www.thecarlyle.com

Price category: $$$$
Rooms: 181 rooms and suites, 60 apartments
Facilities: Restaurant, health club, spa studio
Services: Wonderful concierge service, valet & secretarial service, twice-daily maid service, 24-hour in-room dining service, babysitting, pet friendly
Located: On Madison Avenue, near Central Park and Whitney Museum of American Art
Subway: M, 4, 5, 6 77 Street
Map: No. 5
Style: Contemporary design
What's special: Don your top hat and morning coat, and step back in time as you step into one of New York's most elegant and storied hotels. The Carlyle belongs to Rosewood Hotels & Resorts, one of the finest in luxury hospitality.

Cool Restaurants nearby:
Sant Ambroeus

Cool Shops nearby:
Fragments

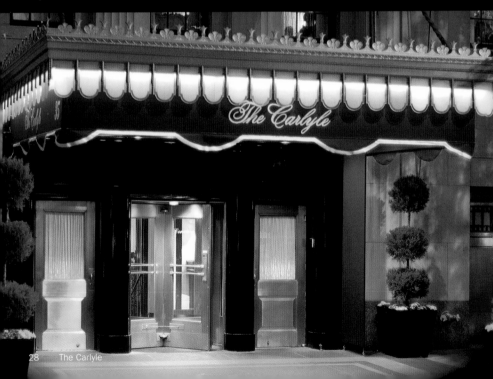

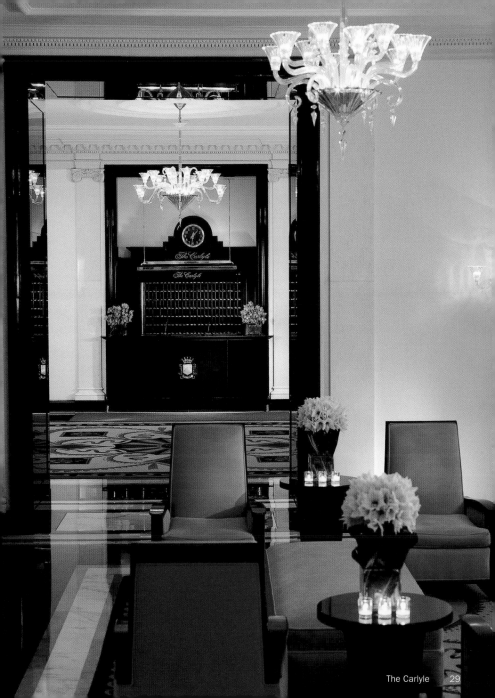

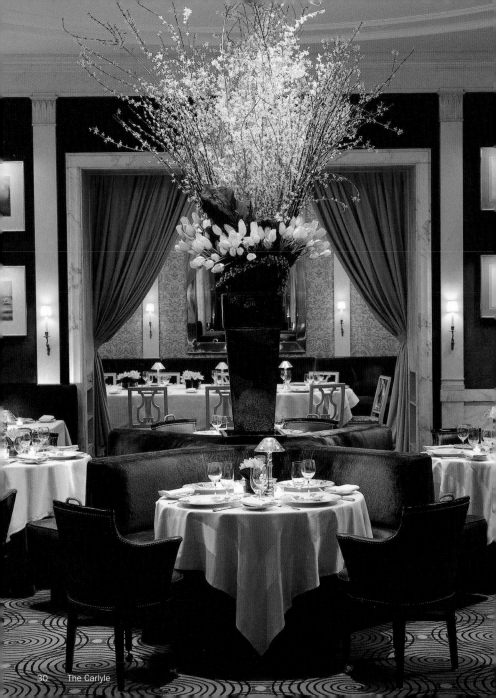

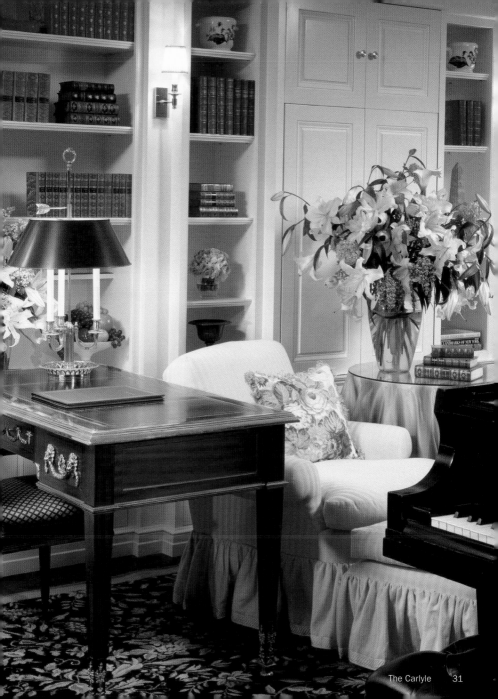

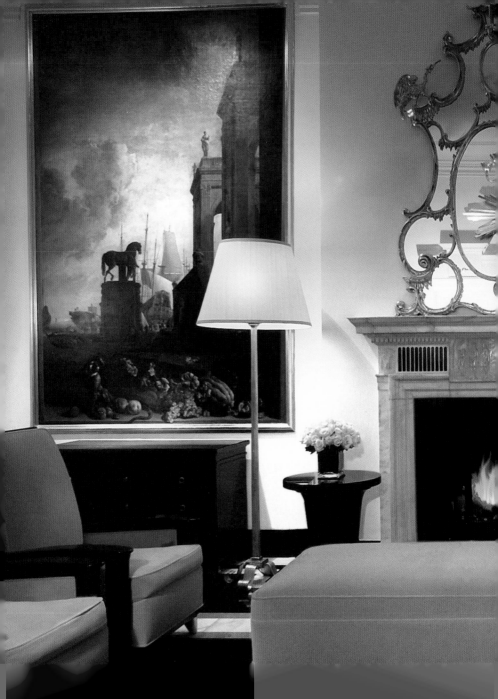

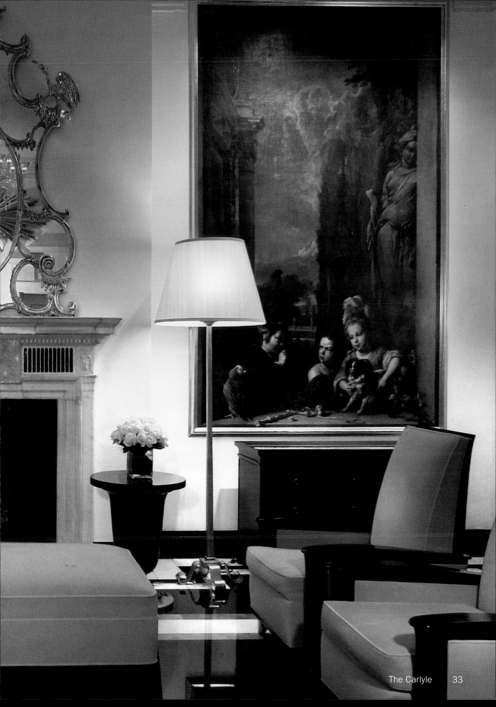

Chambers a hotel

15 West 56th Street
New York, NY 10019
Midtown
Phone: +1 212 974 5656
Fax: +1 212 974 5657
www.chambershotel.com

Price category: $$$$
Rooms: 60 rooms
Facilities: Town restaurant, collection of more than 500 pieces of original artwork
Services: Entertainment and business facilities
Located: Around the corner of the Museum of Modern Art, MoMa
Subway: E, V Fifth Avenue – 53 Street; F 57 Street
Map: No. 6
Style: Contemporary design with modern art collection
What's special: Located in the heart of the 5th Avenue retail district, Chambers a hotel boasts one of the best art collections of any small hotel in the world. Each floor is host to an ever-changing installation by an established artist.

Cool Restaurants nearby:
Nobu Fifty Seven
Lever House Restaurant
Four Seasons Restaurant

Cool Shops nearby:
MoMa Design and Book Store
Rizzoli Bookstore

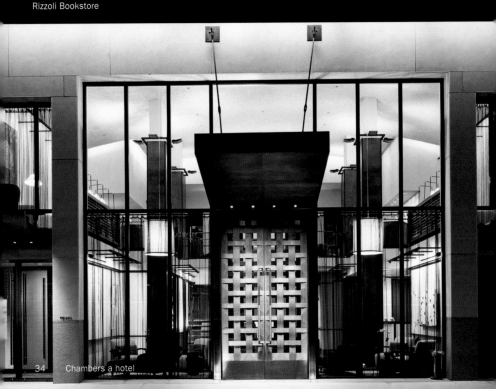

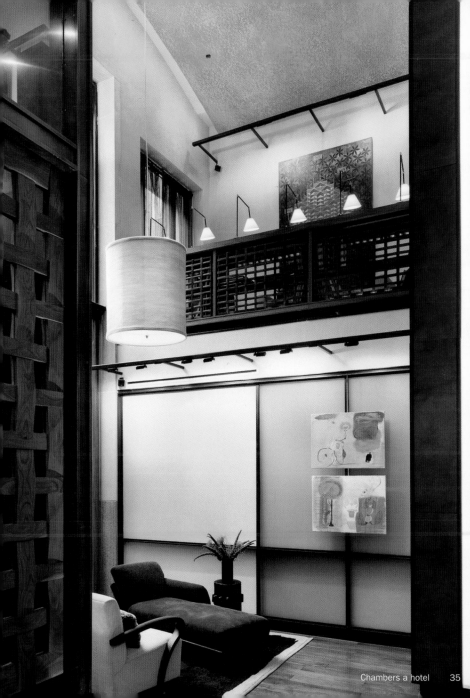

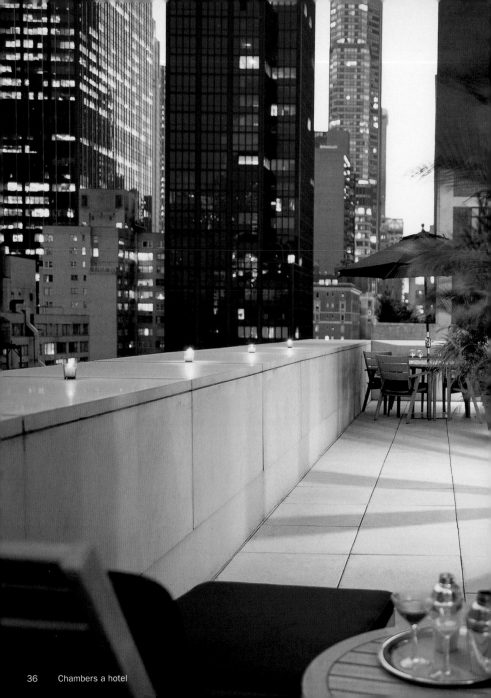

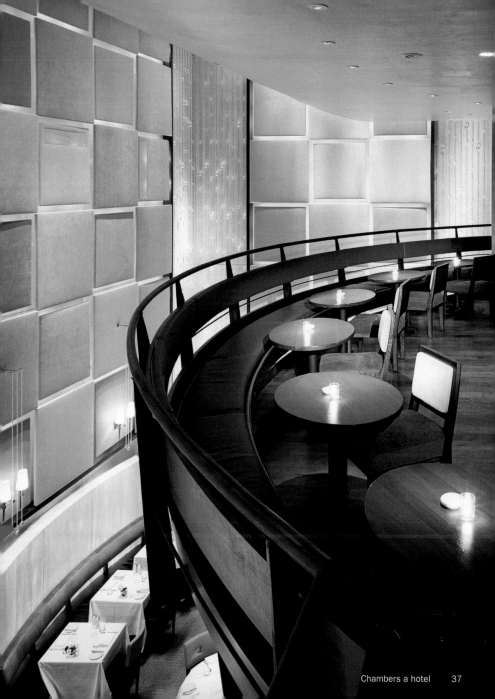

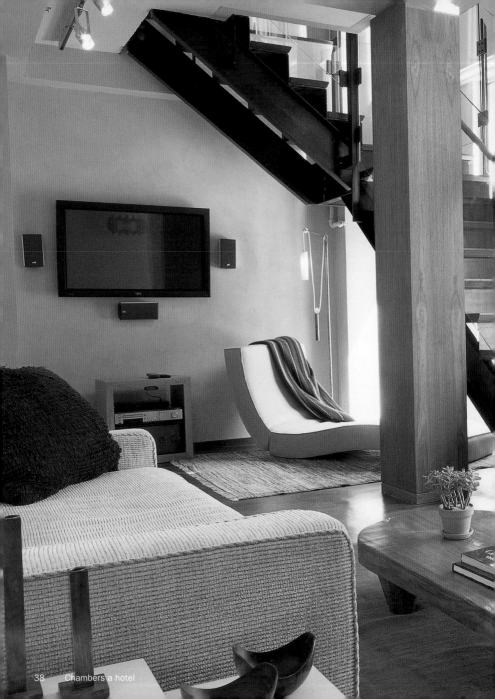

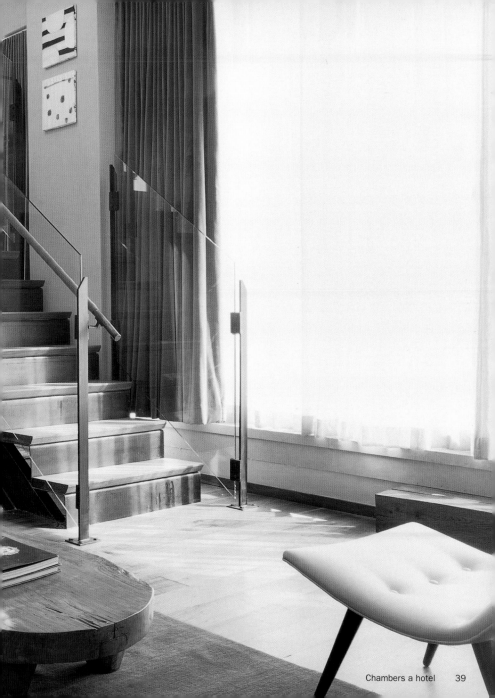

Dream

210 West 55th Street
New York, NY 10019
Midtown
Phone: +1 212 247 2000
Fax: +1 646 756 2088
www.dreamny.com

Cool Restaurants nearby:
Four Seasons Restaurant
Lever House Restaurant

Cool Shops nearby:
MoMa Design and Book Store
Rizzoli Bookstore

Price category: $$$
Rooms: 220 rooms on 13 floors
Facilities: Restaurants Sarafina and Amalia with basement club D'Or, bar, lounge and terrace on rooftop, lounge adjacent to the lobby, spa with Ayurveda center
Services: Include an iPod and a huge plasma TV
Located: Central Park 3 blocks north, Times Square 4 blocks south
Subway: M, Q, R, W 57 Street; B, D, E Seventh Avenue
Map: No. 7
Style: Contemporary design
What's special: Like something from a storybook, it enchants from the moment you cross the threshold. The Ava lounge Penthouse boasts one of the best views in the city, stretching from Times Square to the Hudson River.

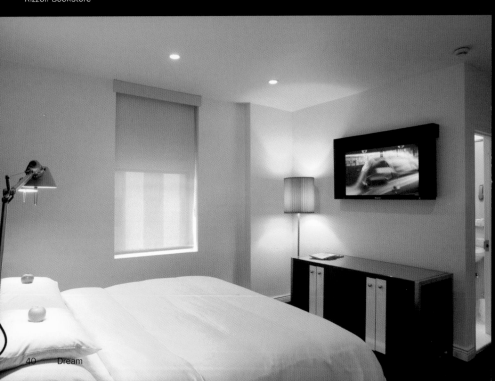

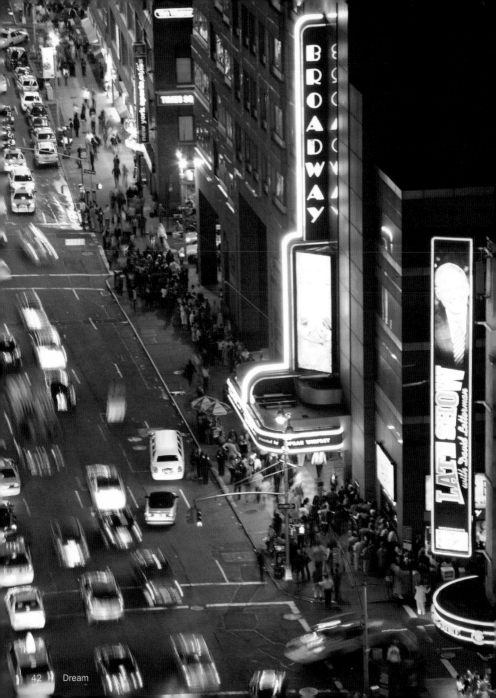

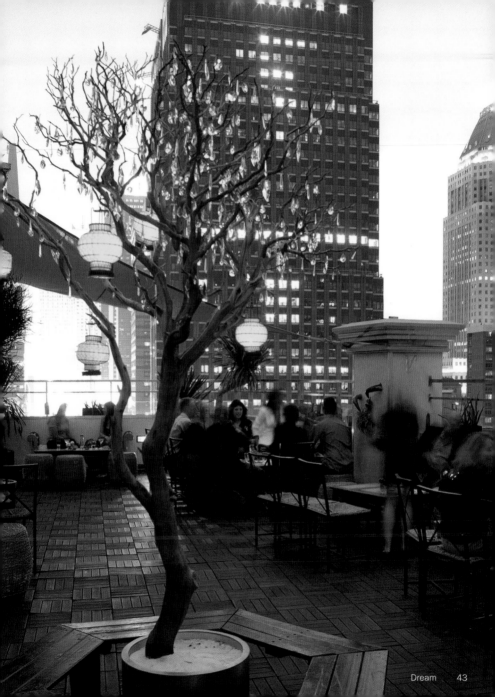

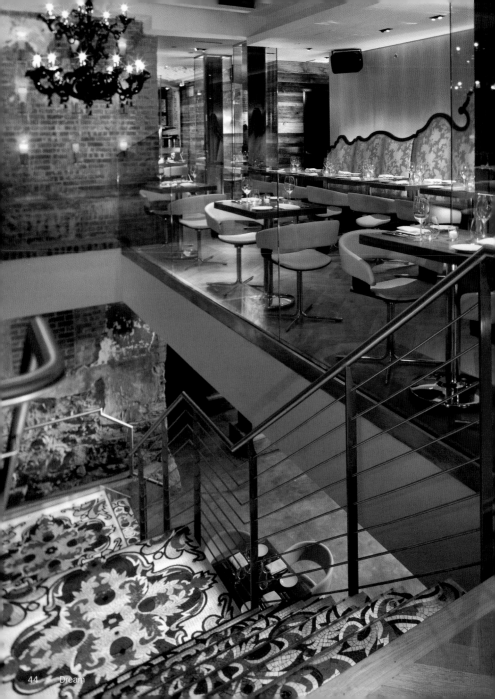

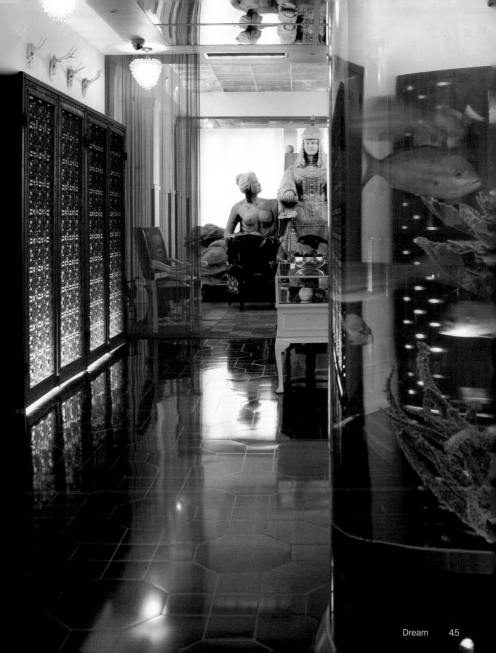

Four Seasons Hotel New York

57 East 57th Street
New York, NY 10022
Midtown
Phone: +1 212 758 5700
Fax: +1 212 758 5711
www.fourseasons.com

Price category: $$$$
Rooms: 368 rooms and suites including 61 upper tower suites
Facilities: Restaurants and lounges, private dining room, fitness center, sauna, spa, whirlpool
Services: Babysitting, limousine service
Located: Only some footsteps away from elegant 5th Avenue and Central Park
Subway: 4, 5, 6 Lexington Avenue – 59 Street
Map: No. 8
Style: Modern classic
What's special: The venerable Four Seasons New York is one of the world's greatest hotels. A favorite of New York's business elite, the three restaurants, including Joël Robuchon's L'Atelier, are the places to see and be seen.

Cool Restaurants nearby:
Lever House Restaurant
Nobu Fifty Seven

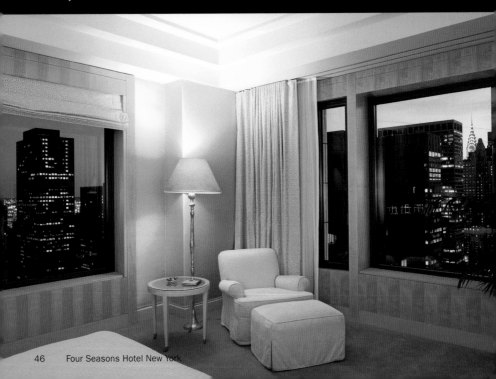

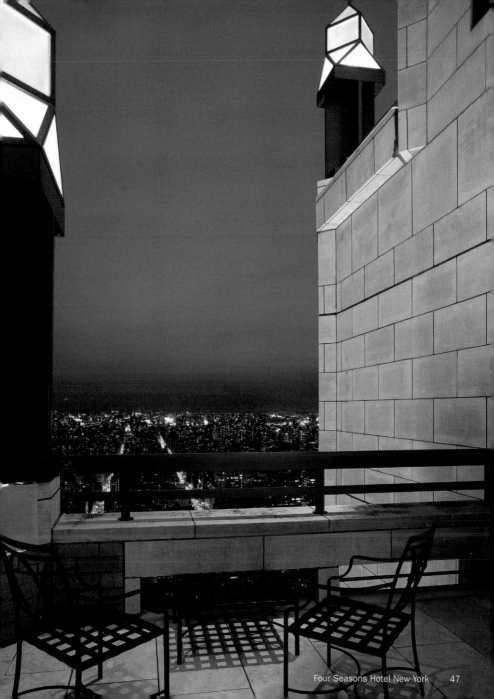

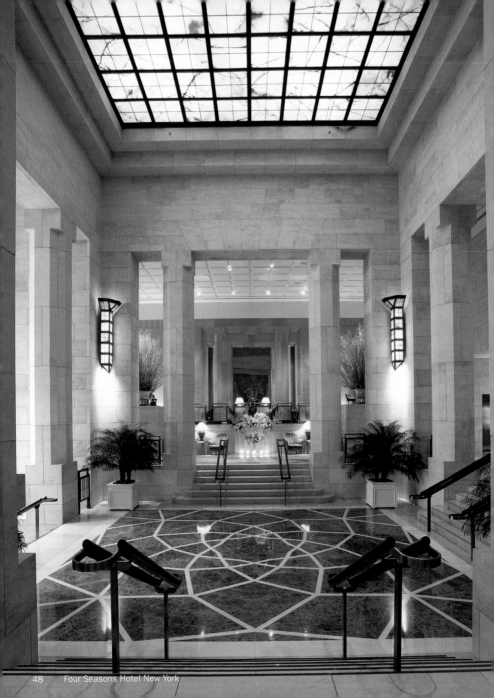

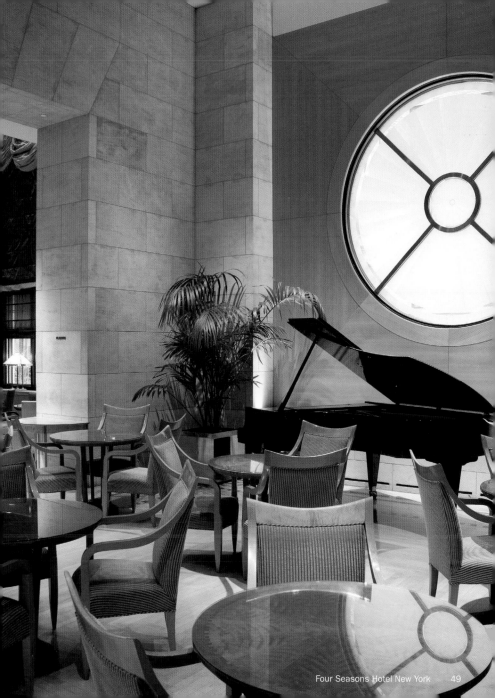

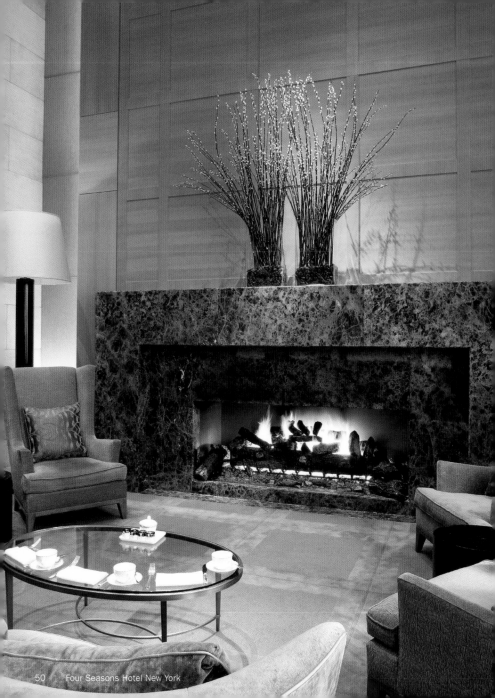

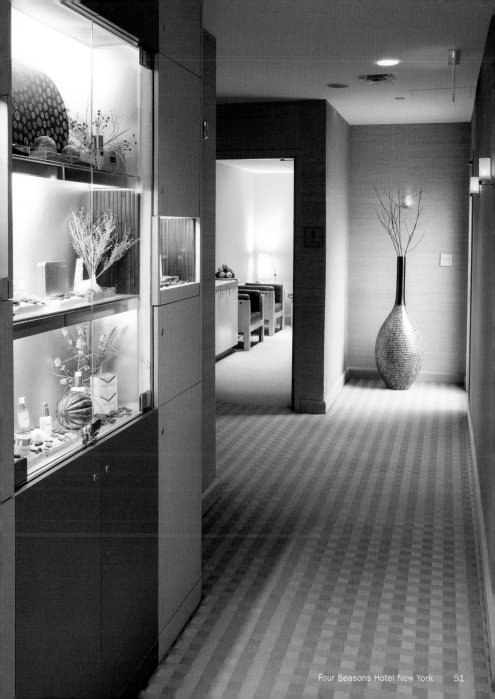

The Franklin Hotel

164 East 87th Street
New York, NY 10128
Upper East Side
Phone: +1 212 369 1000
Fax: +1 212 369 8000
www.franklinhotel.com

Price category: $$
Rooms: 49 cozy rooms on 9 floors
Facilities: Complimentary European-inspired breakfast buffet
Services: 24-hour espresso & cappuccino service, flat screen TV, babysitting, pet friendly, iPod docks, in-room safes
Located: Near Central Park and Museum Mile, Madison Avenue shopping
Subway: M, 4, 5, 6 86 Street
Map: No. 9
Style: French country
What's special: Though the rooms are beautifully appointed and the amenities are in place, it is the service that stops you in your tracks. A smile in New York City may be as rare as a parrot in Central Park, but you will find one on the face of everyone who greets you.

Cool Restaurants nearby:
Sant Ambroeus

Cool Shops nearby:
Fragments

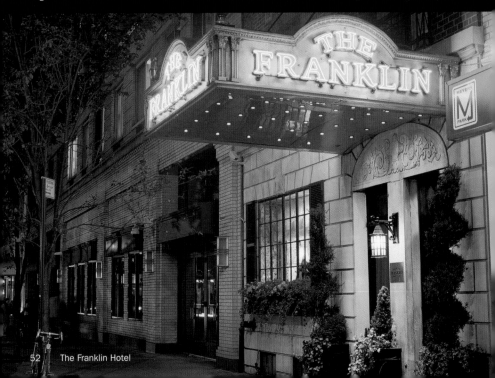

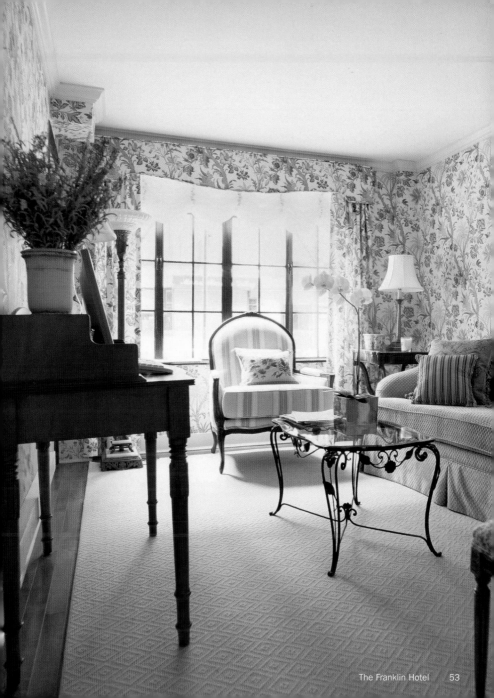

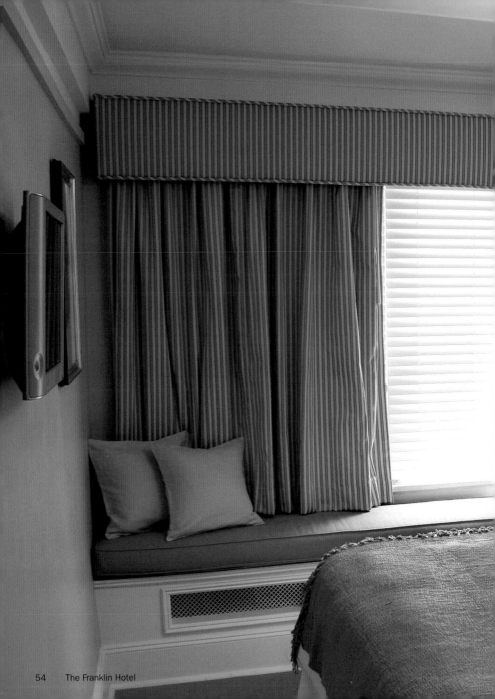

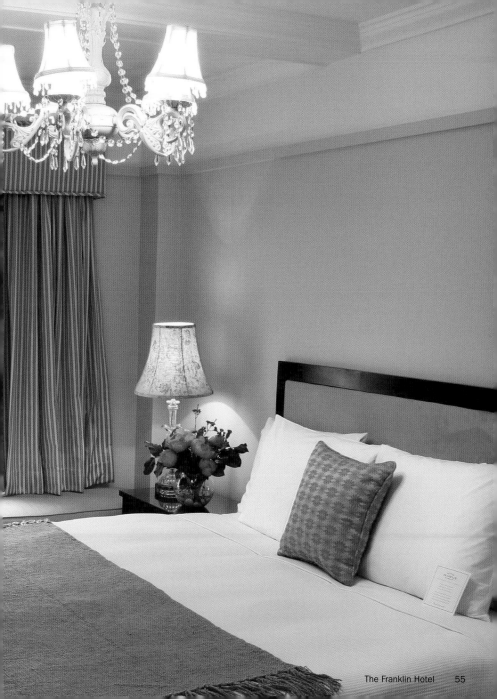

Hotel Gansevoort

18 9th Avenue
New York, NY 10014
Meatpacking District
Phone: +1 212 206 6700
Fax: +1 212 255 5858
www.hotelgansevoort.com

Cool Restaurants nearby:
Perry Street
Wallsé
Spice Market

Cool Shops nearby:
Alexander McQueen
Carlos Miele Flagship Store

Price category: $$$
Rooms: 187 rooms including 20 suites
Facilities: Restaurant, spa, bar, rooftop lounge, glass-surrounded swimming pool with underwater music
Services: Multilingual staff, express check-out
Located: In the Meatpacking District
Subway: A, C, E, L Eighth Avenue – 14 Street
Map: No. 10
Style: Contemporary design
What's special: One of the hottest spots in New York is a pool? If you're a guest at the Hotel Gansevoort it is. The rooftop, with its pool and unparalleled 360 degree views of the skyline, plays host to some of Manhattan's most stylish events.

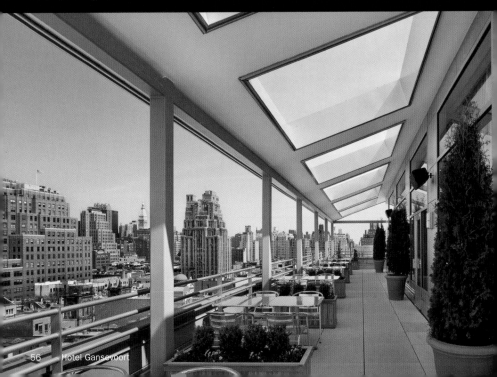

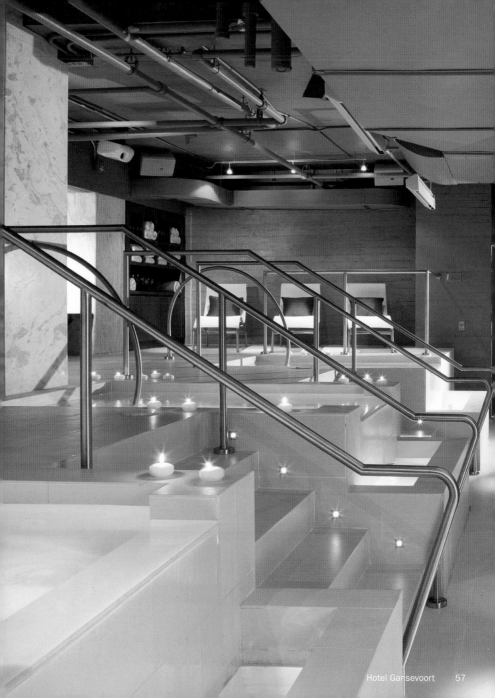

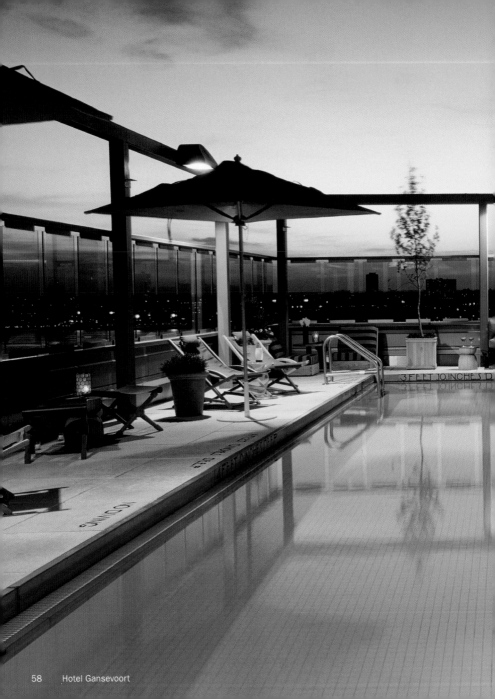

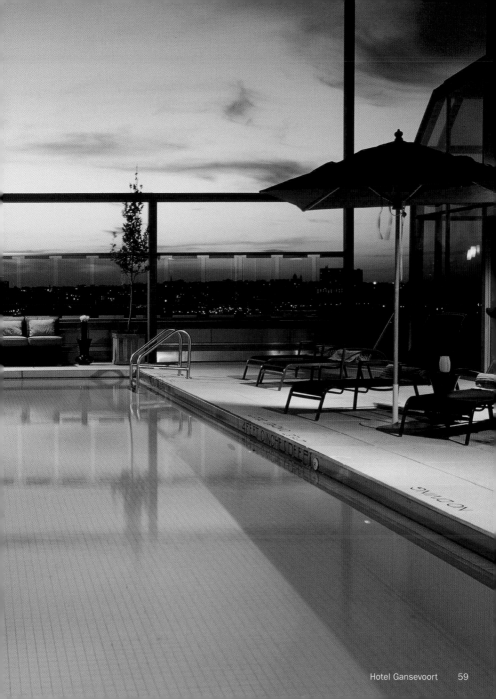

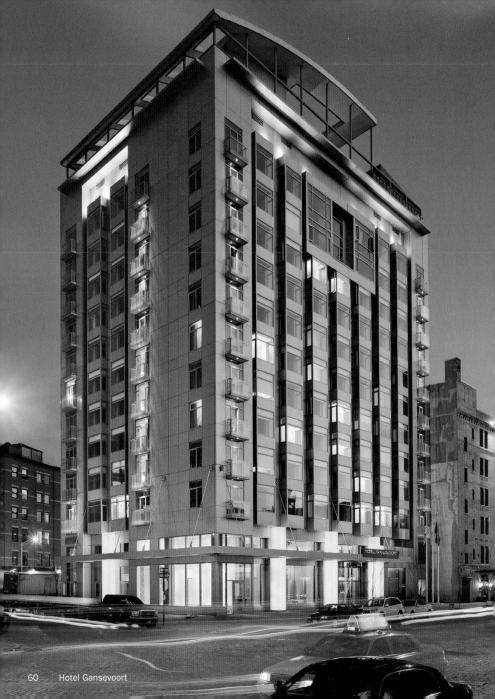

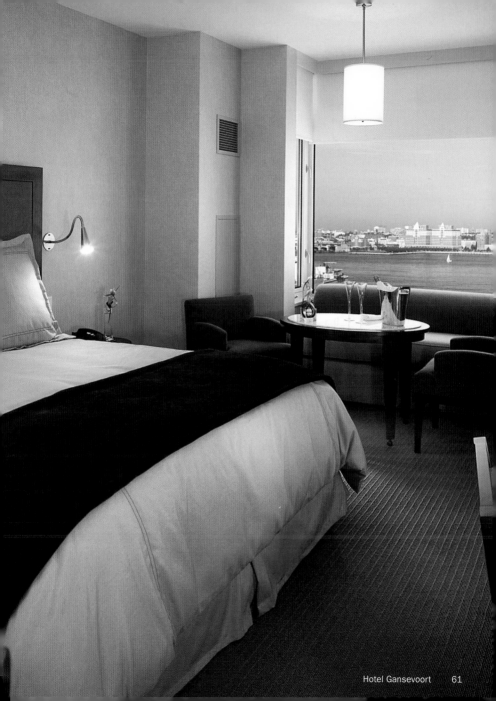

Hotel Giraffe

365 Park Avenue South
New York, NY 10016
Union Square
Phone: +1 212 685 7700
Fax: +1 212 685 7771
www.hotelgiraffe.com

Price category: $$$
Rooms: 73 guestrooms, including 21 suites
Facilities: Bar, roof garden open to the public for cocktails
and tapas in the evening from mid-May to October,
especially on Saturdays
Services: European style deluxe continental breakfast,
Internet access, use of DVD, video and CD library
Located: Near Madison Square Park
Subway: M, 6 28 Street
Map: No. 11
Style: Contemporary design
What's special: Voted best boutique hotel, top three best
business hotels and one of the top ten most popular ho-
tels of its size in New York City, this stylish small hotel
is known for its casual elegance and year-round appeal.

Cool Restaurants nearby:
Dévi

Cool Shops nearby:
ABC Carpet & Home
Miya Shoji

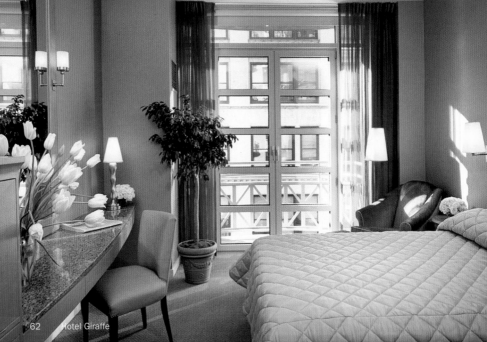

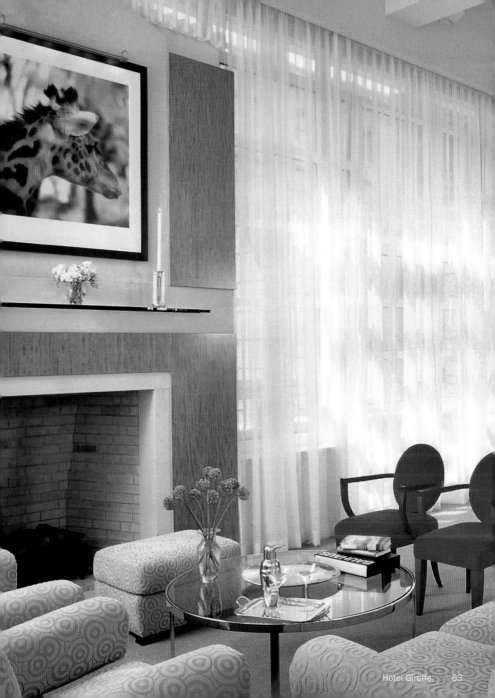

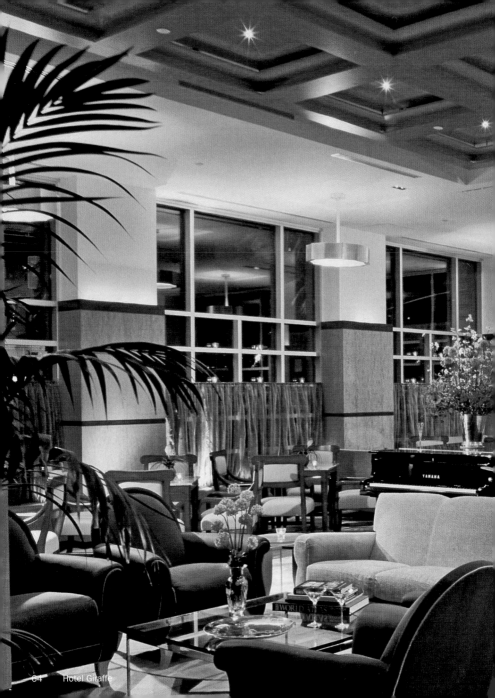

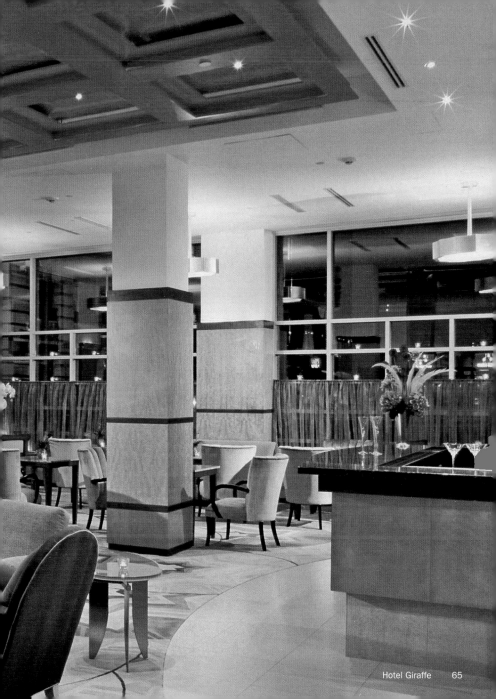

Hotel 57

130 East 57th Street
New York, NY 10022
Midtown
Phone: +1 212 753 8841
Fax: +1 212 838 4767
www.hotel57.com

Cool Restaurants nearby:
Nobu Fifty Seven
Four Seasons Restaurant

Cool Shops nearby:
The Conran Shop

Price category: $$$$
Rooms: 220 deluxe rooms and suites
Facilities: Hotel 57's 17th floor terrace provides panoramic views of New York City including the Chrysler Building
Services: Hi-speed Internet access/laptop-compatible, flat screen TV
Located: Just footsteps away from Central Park
Subway: M, 4, 5, 6 Lexington Avenue – 59 Street
Map: No. 12
Style: Cozy and romantic
What's special: The soaring modernist lobby, coupled with wood-lined rooms that feel at once cozy and intimate and timelessly grand, make it a great choice for travelers looking for luxury and serenity in a central location.

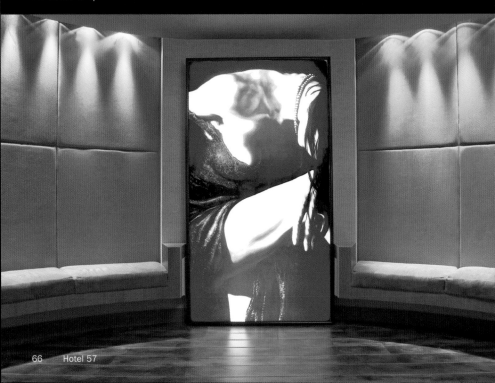

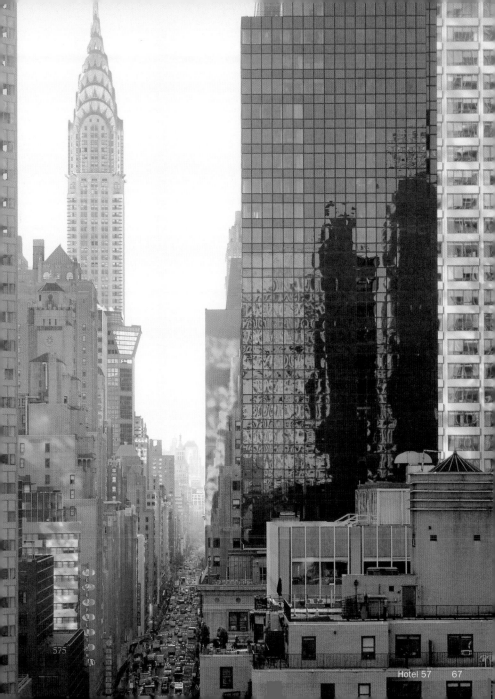

Inn at Irving Place

56 Irving Place
New York, NY 10003
Union Square
Phone: +1 212 533 4600
Fax: +1 212 533 4611
www.innatirving.com

Price category: $$$
Rooms: 12 rooms and suites
Facilities: Restaurant, Cibar lounge
Services: Beauty parlor and day spa
Located: Near Gramercy Park and Union Square Park
Subway: M, 4, 5, 6 14 Street – Union Square
Map: No. 13
Style: Classic elegance and country chic
What's special: Like something from another time, this hotel is actually two brownstone buildings combined to create a hotel experience that marries the elegance of the last century with the style and service of today.

Cool Restaurants nearby:
Dévi

Cool Shops nearby:
ABC Carpet & Home
Miya Shoji

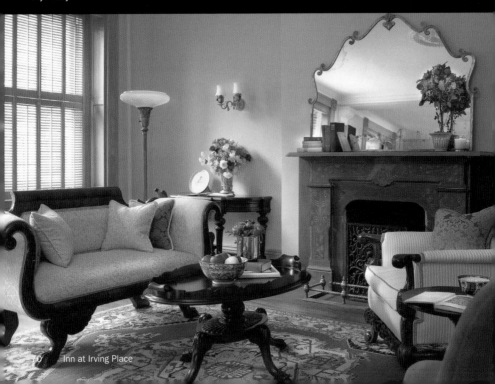

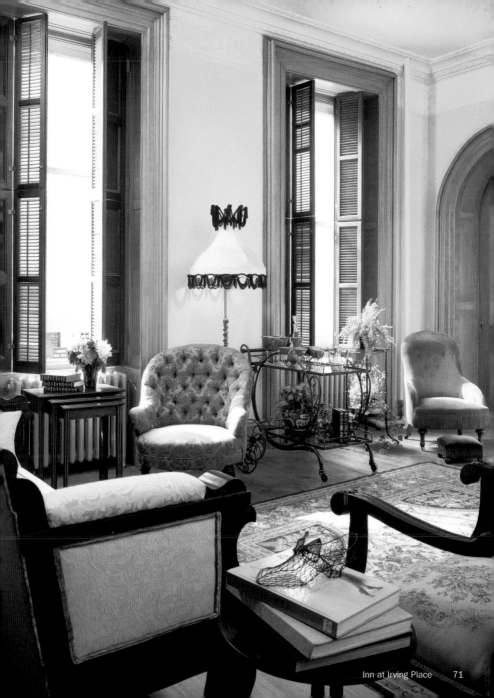

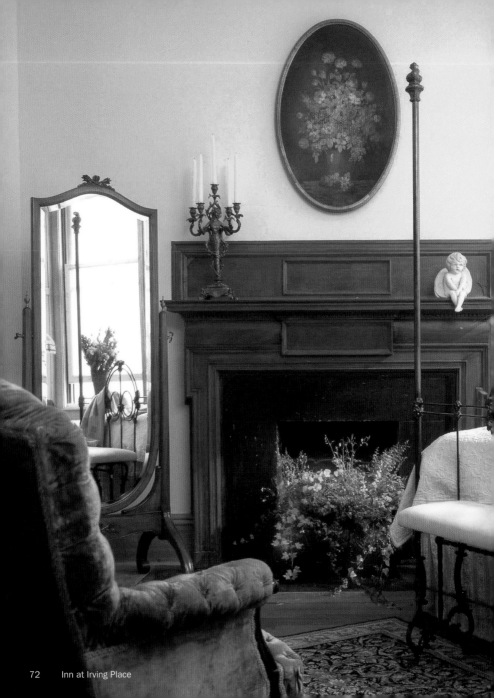

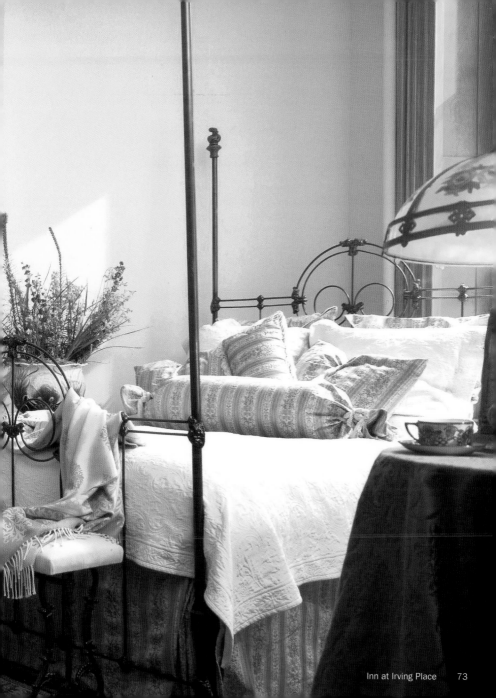

Library Hotel

299 Madison Avenue
New York, NY 10017
Midtown
Phone: +1 212 983 4500
Fax: +1 212 499 9099
www.libraryhotel.com

Cool Restaurants nearby:
Keens Steakhouse
Four Seasons Restaurant
Lever House Restaurant

Cool Shops nearby:
MoMa Design and Book Store

Price category: $$$
Rooms: 60 rooms
Facilities: Reading room on 2nd floor with snacks, complimentary wine and cheese each evening from 5 to 8 pm
Services: DVD and book library, complimentary continental breakfast
Located: Next to the New York Public Library
Subway: M, 7 Fifth Avenue; S, M, 4, 5, 6 Grand Central – 42 Street
Map: No. 14
Style: Modern classic
What's special: The rooms are numbered according to the Dewey Decimal System and each room is fully stocked with books according to single subjects. You will never tire of the Library Hotel.

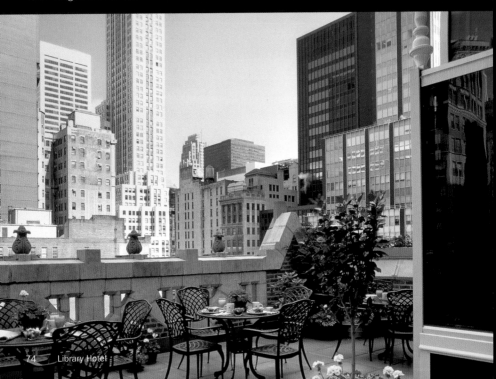

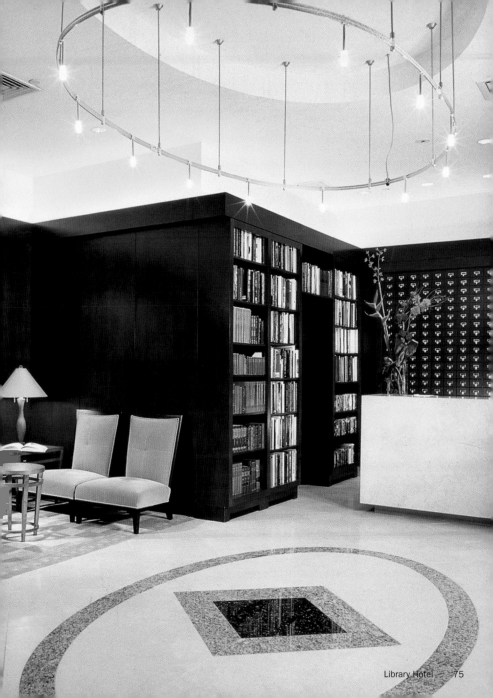

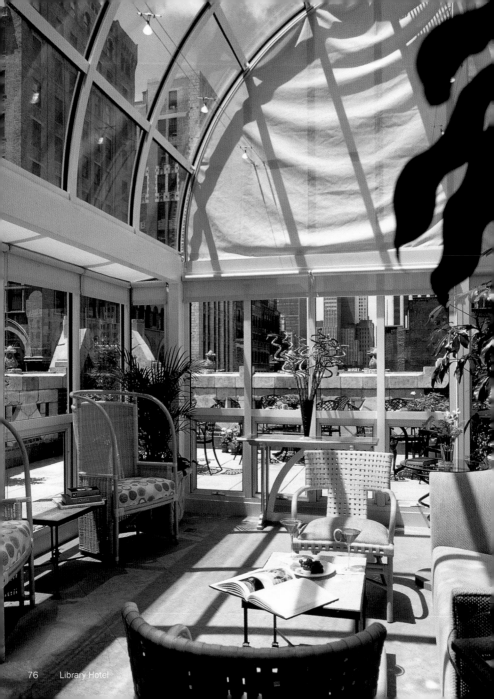

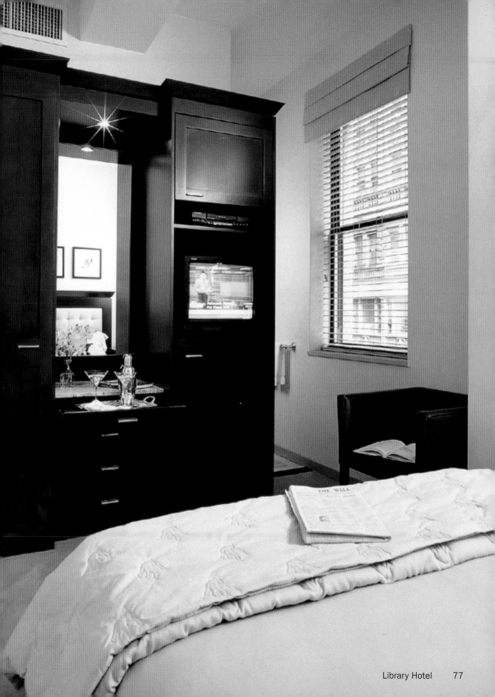

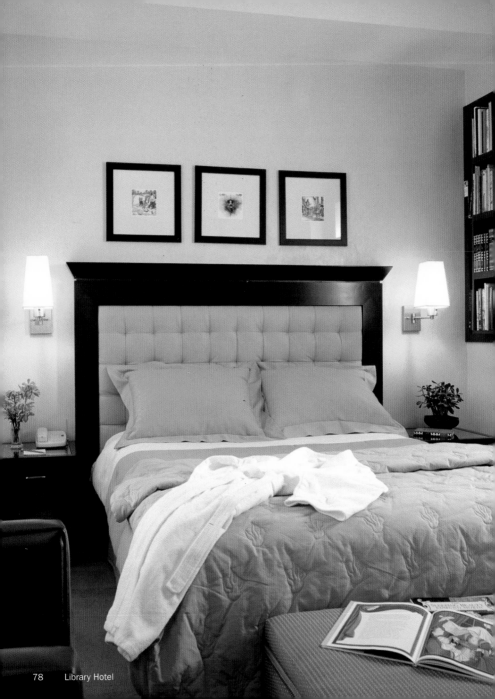

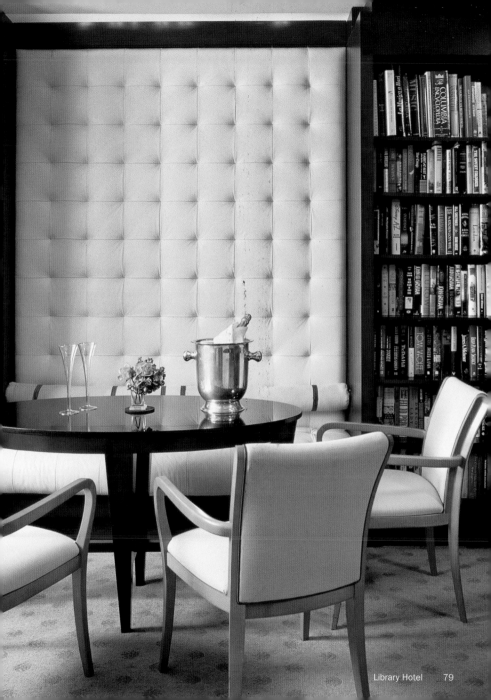

The Lowell

28 East 63rd Street
New York, NY 10021
Upper East Side
Phone: +1 212 838 1400
Fax: +1 212 319 4230
www.lowellhotel.com

Price category: $$$$
Rooms: 23 individually decorated suites and 21 deluxe rooms
Facilities: Restaurant, fitness center, Fiji water, fireplaces
Services: Multilingual staff
Located: East 63rd Street between Madison and Park Avenues
Subway: F Lexington Avenue – 63 Street
Map: No. 15
Style: Classic elegance
What's special: You're weary and tired from a day of work or shopping on the bustling streets of Manhattan. When you arrive in your room, your working fireplace has been lit, afternoon tea has been poured and your worries have been quelled for at least another day.

Cool Restaurants nearby:
Sant Ambroeus

Cool Shops nearby:
Fragments

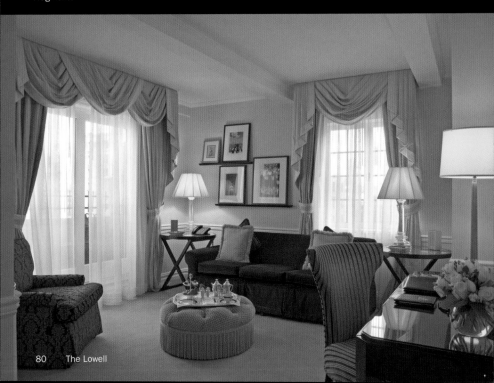

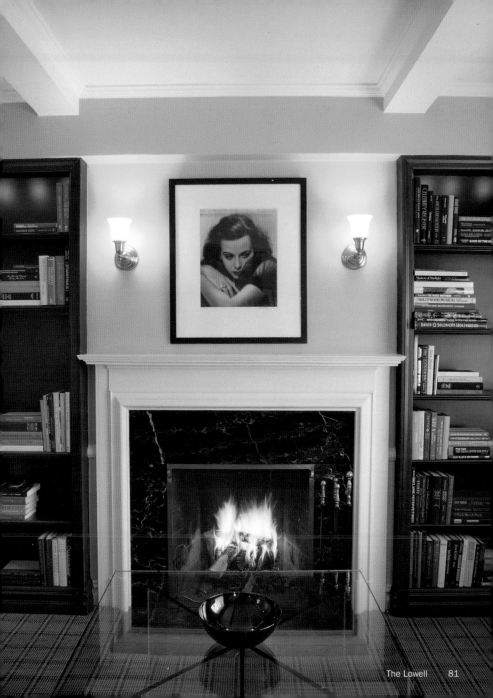

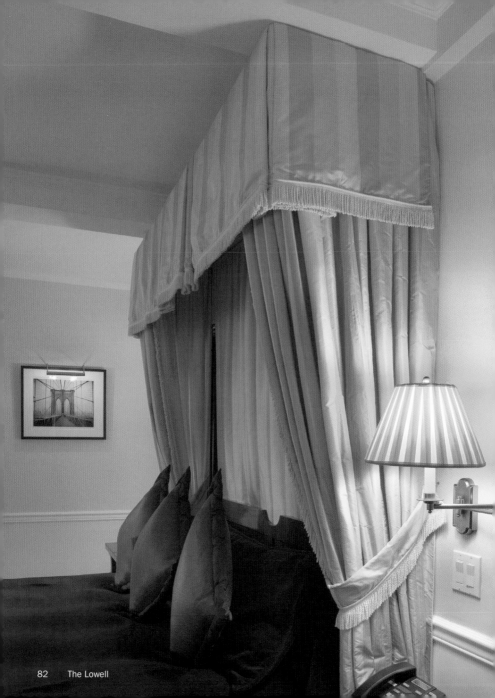

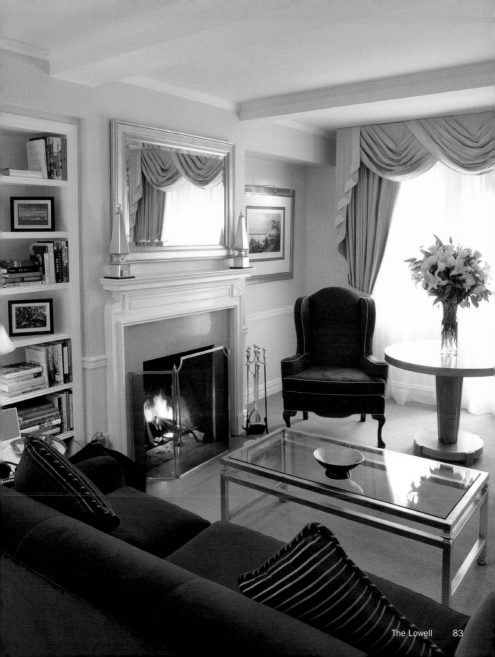

Mandarin Oriental, New York

80 Columbus Circle
New York, NY 10023
West Side
Phone: +1 212 805 8800
Fax: +1 212 805 8888
www.mandarinoriental.com/newyork

Price category: $$$$
Rooms: 248 rooms and suites
Facilities: Restaurant, bar, spa, fitness center, lobby lounge on the 35th floor
Services: Internet access, full-service business center, 24-hour in-room dining, housekeeping, guest services
Located: Just footsteps away from the Central Park
Subway: A, B, C, D, 1 59 Street – Columbus Circle
Map: No. 16
Style: Contemporary design
What's special: Known for its Asian-inspired elegance, the Mandarin Oriental has one of New York's most lavish presidential suites: multiple bedrooms, onyx walled bathrooms and understated, timeless décor make for an unforgettable experience.

Cool Restaurants nearby:
Sant Ambroeus
Lever House Restaurant

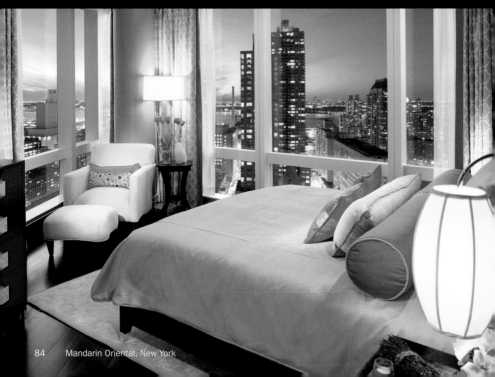

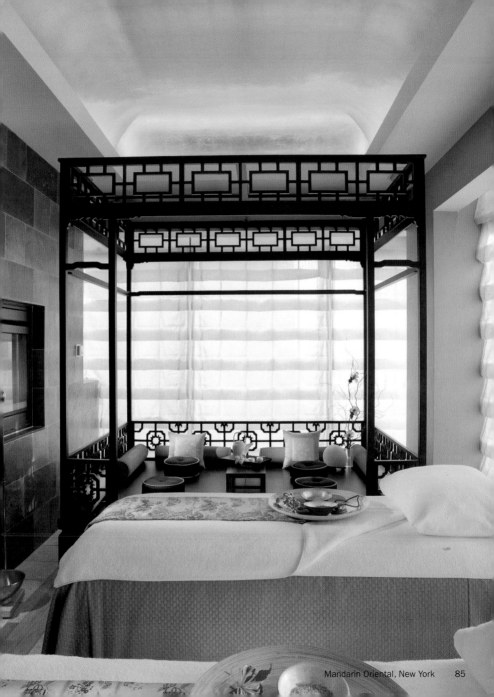

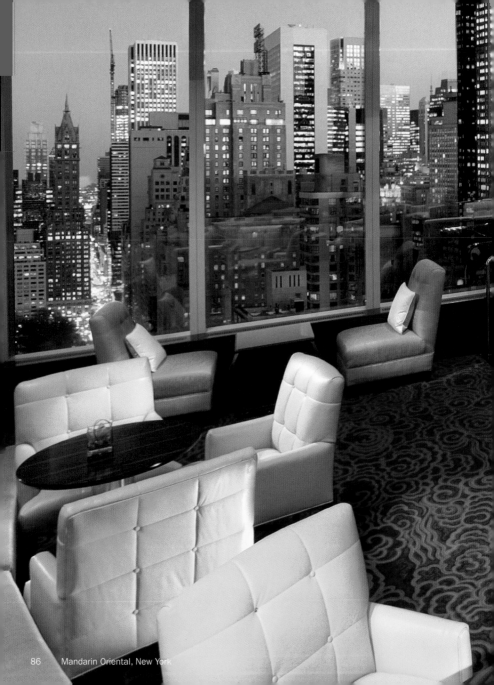

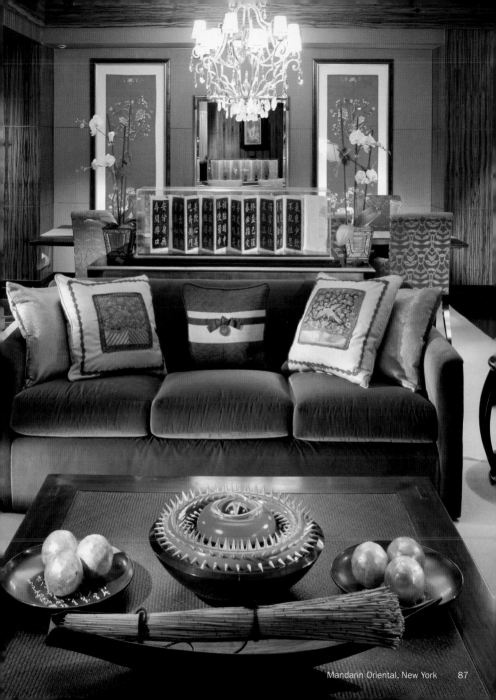

363 West 16th Street
New York, NY 10010
Chelsea
Phone: +1 212 242 4300
Fax: +1 212 242 1188
www.themaritimehotel.com

Cool Restaurants nearby:
Matsuri

Cool Shops nearby:
Jeffrey
Miya Shoji

Price category: $$$
Rooms: 125 rooms
Facilities: Restaurants, lobby bar, The Cabanas Roof Bar
Services: Internet access, collection of 400 CDs and DVDs
Located: Two blocks north of the Meatpacking District
Subway: A, C, E, L Eighth Avenue – 14 Street
Map: No. 17
Style: Contemporary design
What's special: Don't miss the lobby bar at The Maritime Hotel, home to more than a few trysts since it recently opened. And during the summer months, the Maritime's al fresco bar hosts some of the hottest (pun intended) outdoor action in Manhattan

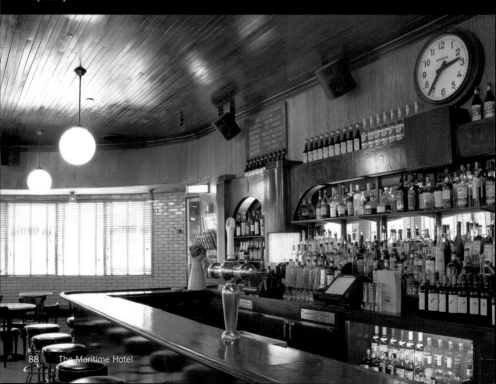

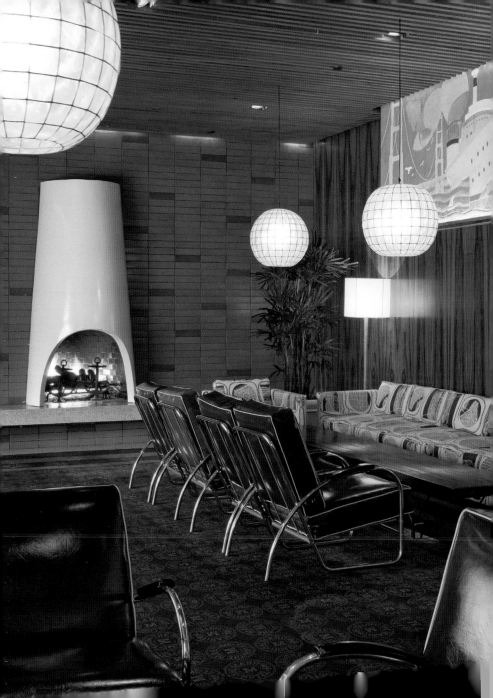

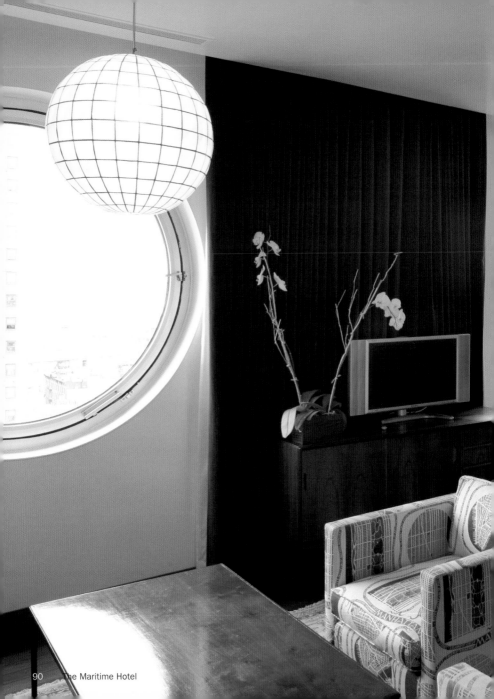

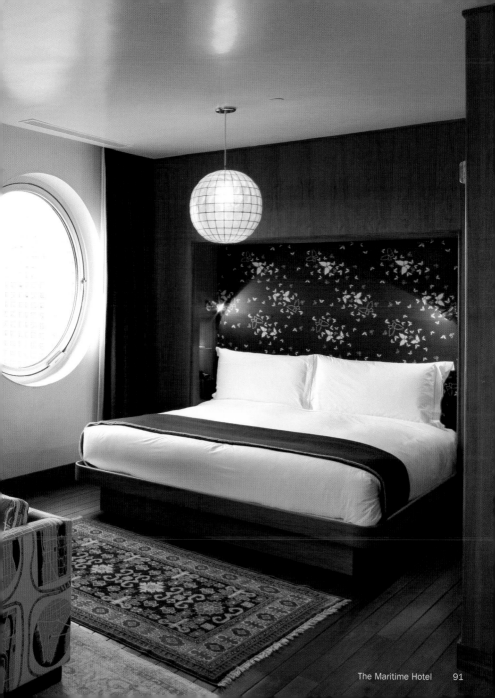

The Mercer

147 Mercer Street
New York, NY 10012
SoHo
Phone: +1 212 966 6060
Fax: +1 212 965 3838
www.mercerhotel.com

Cool Restaurants nearby:
Mercer Kitchen
Peasant
Freemans

Cool Shops nearby:
R by 45rpm
Dean & Deluca
A.P.C.

Price category: $$$$
Rooms: 75 rooms
Facilities: Restaurant, bar
Services: 24-hour room service and lobby food, library,
limousine service
Located: In SoHo
Subway: R, W Prince Street
Map: No. 18
Style: Contemporary design
What's special: Stylish, understated and painfully
chic, The Mercer is quintessentially New York. An André
Balazs property, The Mercer's luxuries include oversized
marble tubs and a fabulous lobby library.

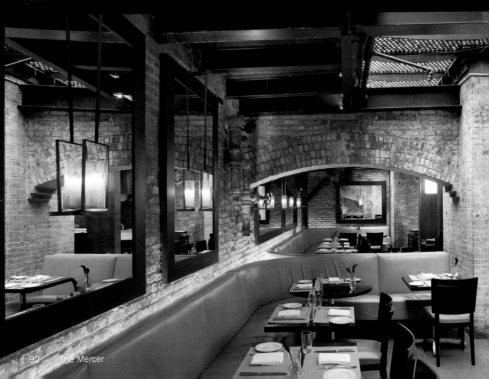

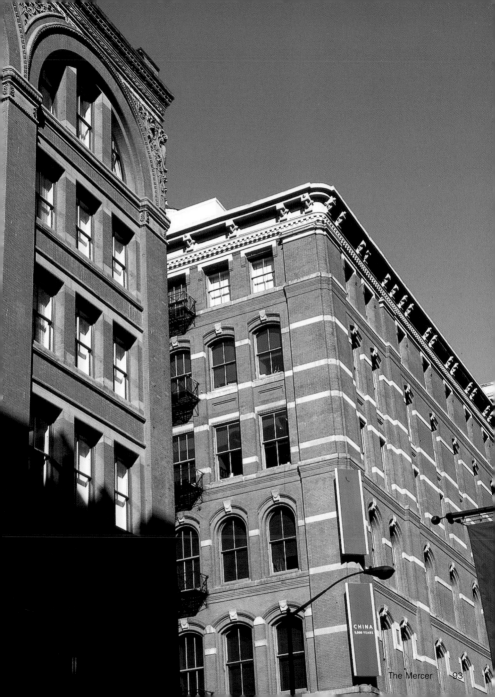

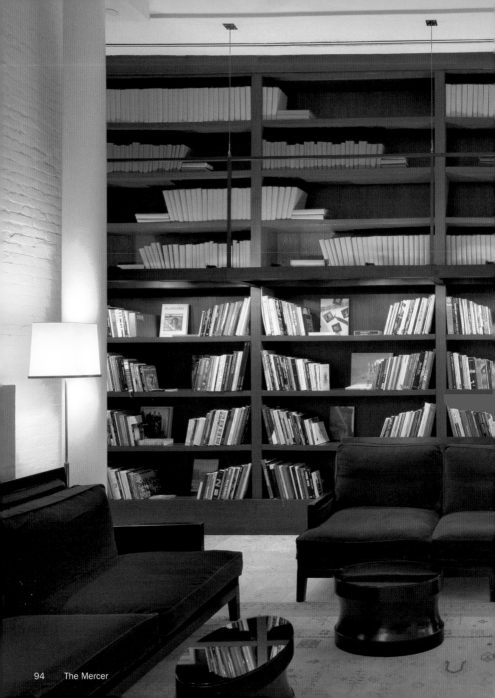

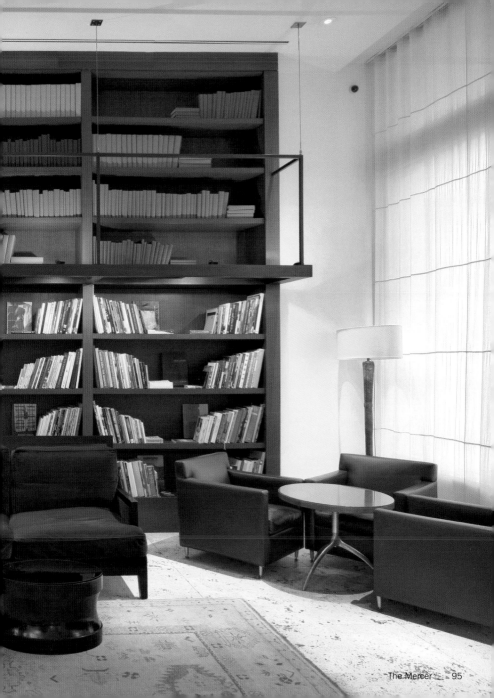

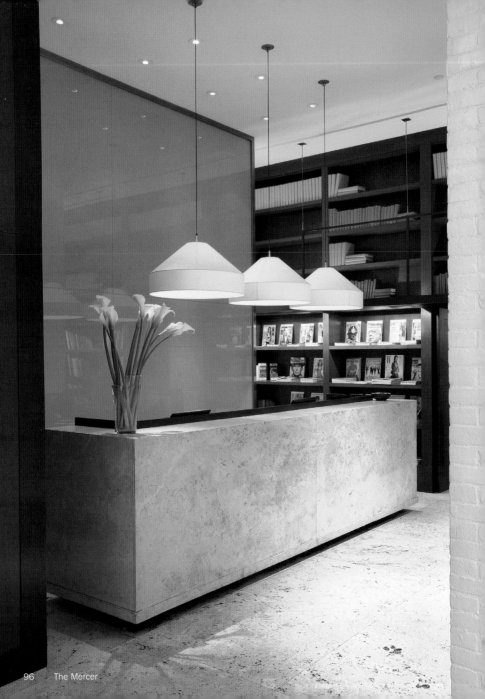

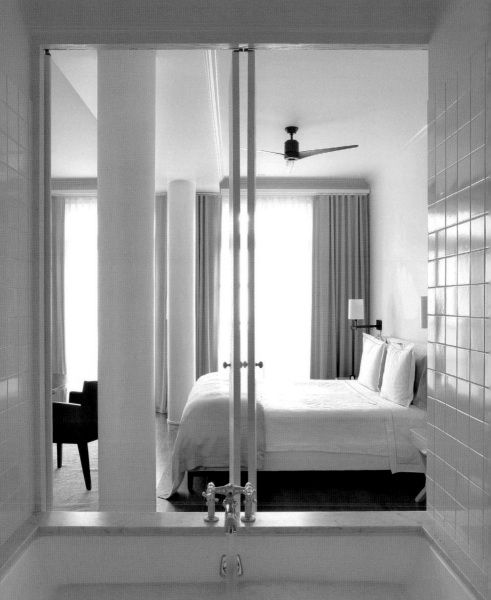

The Moderne

243 West 55th Street
New York, NY 10019
Midtown
Phone: +1 212 397 6767
Fax: +1 212 397 8787
www.nychotels.com

Price category: $$
Rooms: 37 rooms
Facilities: 24-hour cappuccino bar, decorated in ultra contemporary style
Services: Multilingual service
Located: Near Times Square, MoMa, Broadway Theater District
Subway: B, D, E Seventh Avenue; N, Q, R, W 57 Street
Map: No. 19
Style: Contemporary design
What's special: The concepts of modernity and comfort come together to create a stylish and relaxing hotel with some of the largest rooms in this price category. The views from the lounge are not to be missed.

Cool Restaurants nearby:
Keens Steakhouse
Nobu Fifty Seven

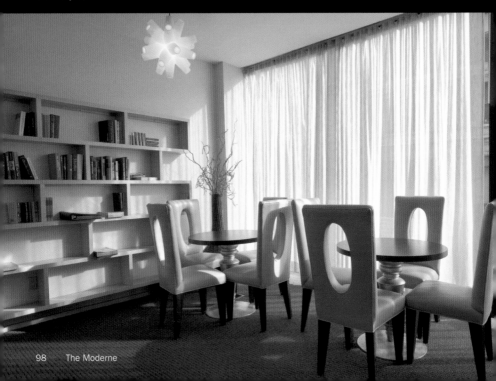

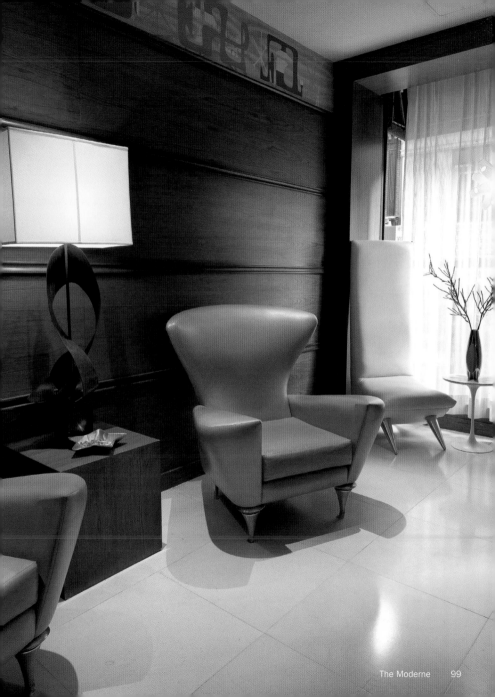

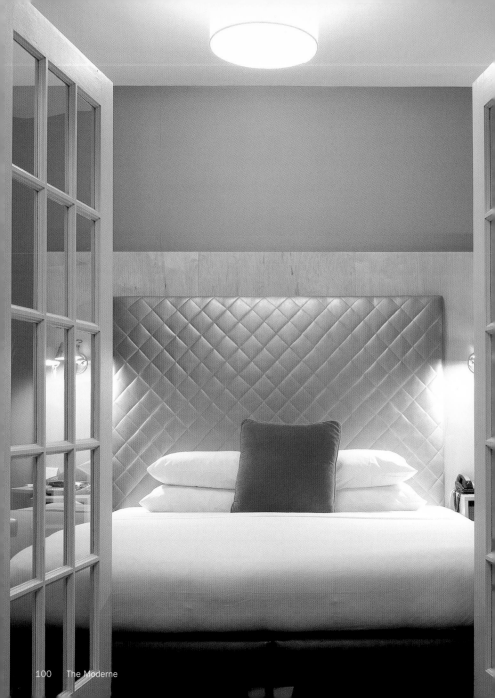

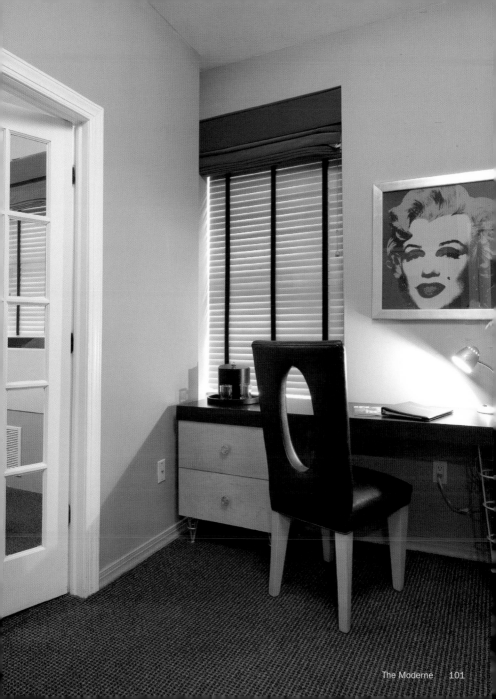

Night

132 West 45th Street
New York, NY 10036
Midtown
Phone: +1 212 835 9600
Fax: +1 212 835 9610
www.nighthotelny.com

Price category: $$
Rooms: 72 rooms
Facilities: Restaurant, bar, yoga, chopra center
Services: Pet friendly, babysitting
Located: Between Times Square and Rockefeller Center
Subway: A, E, C, 1, 2, 3, 7, N, R, Q, W, S, 4 42 Street
– Times Square
Map: No. 20
Style: Urban chic
What's special: Don't forget to pack your ball gag and
your nipple clamps, this gothic-themed, bondage-inspired
hotel is among the city's sexiest lodging options.

Cool Restaurants nearby:
Keens Steakhouse
Lever House Restaurant

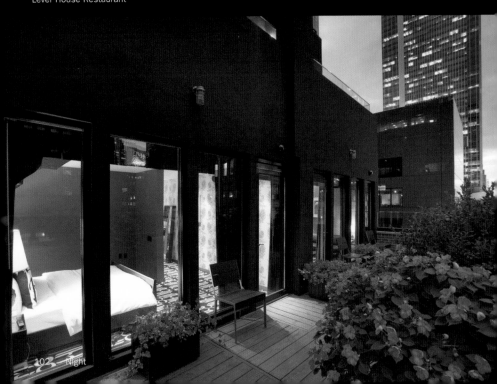

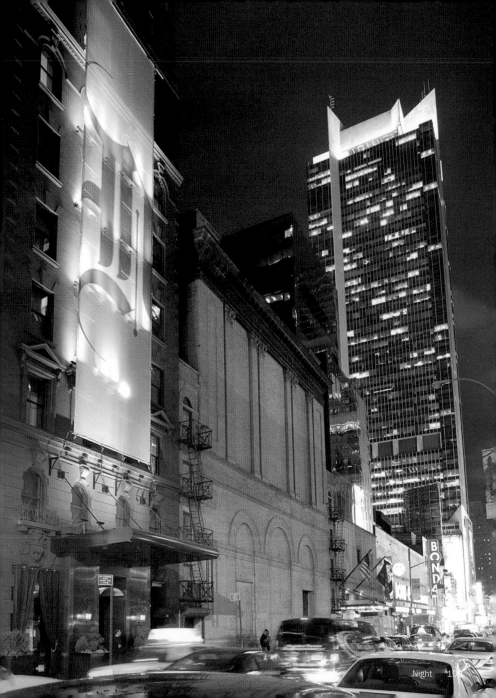

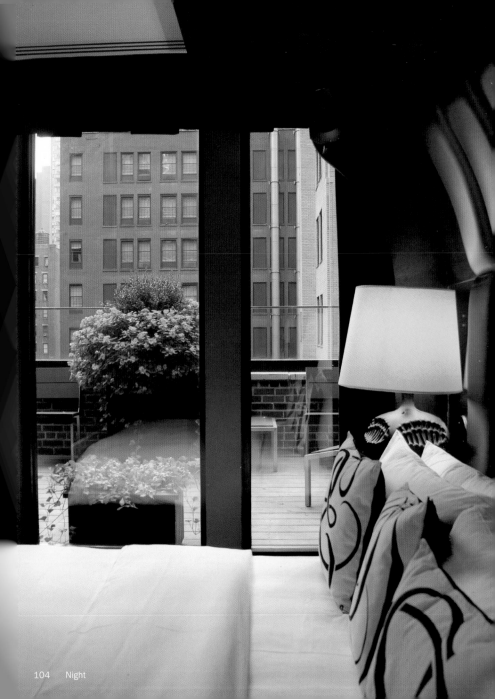

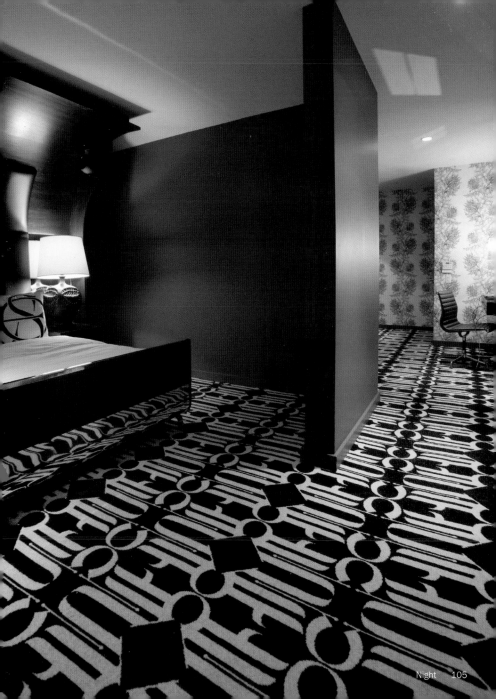

Plaza Athénée

37 East 64th Street
New York, NY 10021
Upper East Side
Phone: +1 212 734 9100
Fax: +1 212 772 0958
www.plaza-athenee.com

Price category: $$$$
Rooms: 114 elegant guest rooms, 35 suites
Facilities: Bar Seine and lounge, restaurant Arabelle, banquet and meeting rooms seating up to 100 guests
Services: Business center, fitness center, 24-hour room service, complimentary laptop, internet in lounge
Located: On a quiet, tree-lined street surrounded by Central Park and Madison Avenue shopping
Subway: F Lexington Avenue – 63rd Street
Map: No. 21
Style: Classic elegance
What's special: This stately, dignified property on the Upper East Side is often voted one of the best hotels in the world. An oasis of European-inspired elegance and service, it is not to be missed.

Cool Restaurants nearby:
Sant Ambroeus

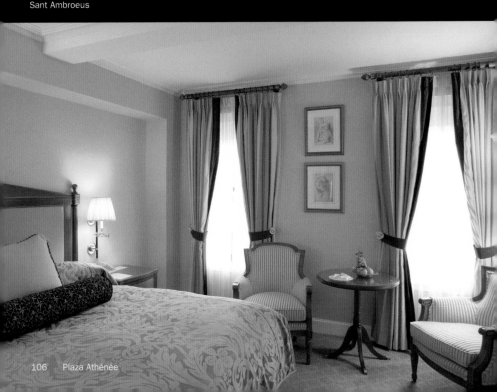

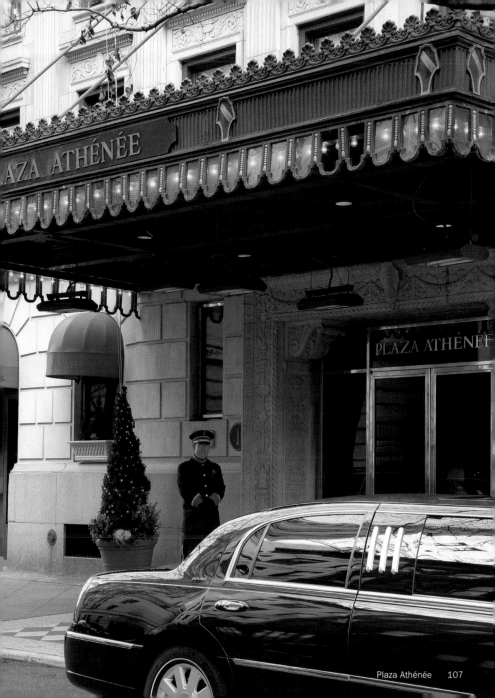

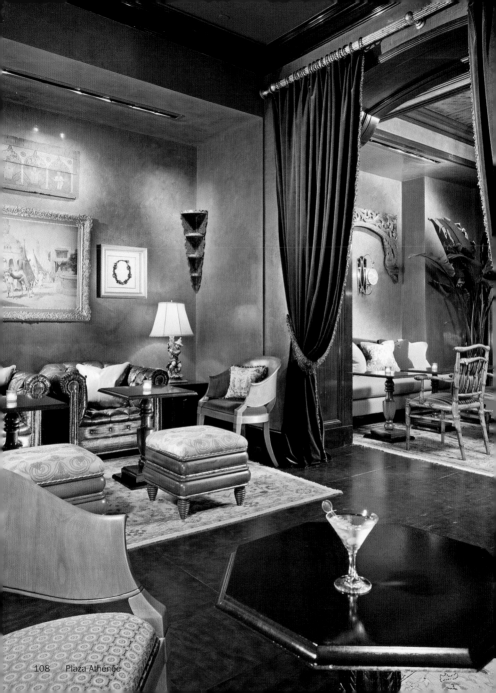

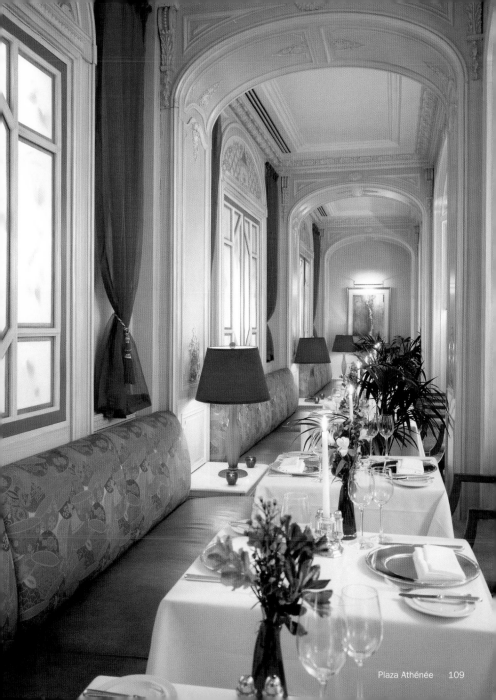

The Pod Hotel

230 East 51st Street
New York, NY 10022
Midtown East
Phone: +1 212 355 0300
Fax: +1 212 755 5029
www.thepodhotel.com

Price category: $
Rooms: 347 rooms
Facilities: Restaurant, lounge, rooftop terrace
Services: Multilingual staff
Located: Near Radio City Music Hall, between The
United Nations Plaza and St. Patrick's Cathedral
Subway: M, 6 51 Street
Map: No. 22
Style: Contemporary design
What's special: Finally a hotel for the rest of us. Not
only are you allowed to take off all of your clothes and
jump on the beds, turn your music up loud and call all of
your friends over for a pillow fight, this hotel expects it!

Cool Restaurants nearby:
Four Seasons Restaurant
Lever House Restaurant

Cool Shops nearby:
MoMa Design and Book Store

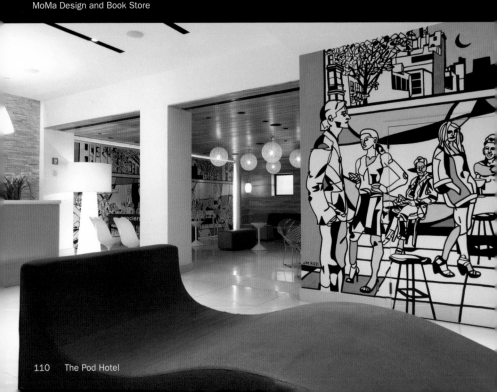

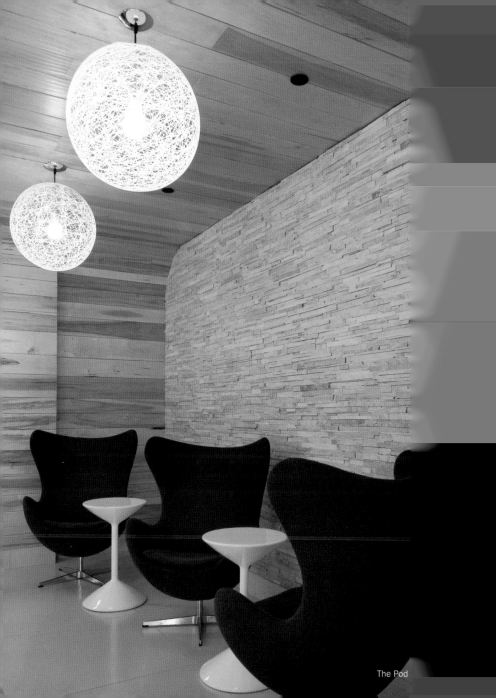

The Pod

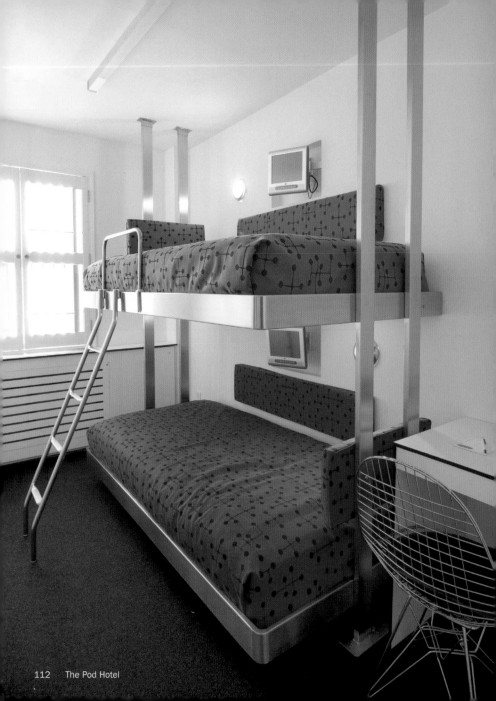

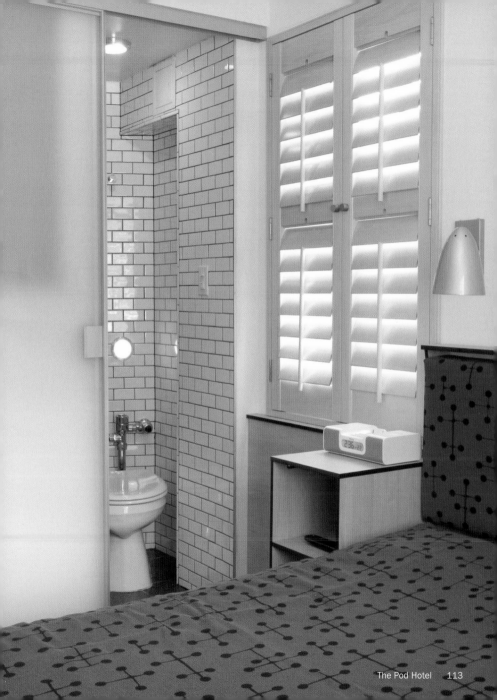

Hotel QT

125 West 45th Street
New York, NY 10036
Midtown
Phone: +1 212 354 2323
Fax: +1 212 302 8585
www.hotelqt.com

Cool Restaurants nearby:
Keens Steak House
Lever House Restaurant

Cool Shops nearby:
MoMa Design and Book Store

Price category: $$
Rooms: 140 rooms
Facilities: Bar and lounge, sauna, steam room, fitness room, lobby pool with swim-up bar
Services: Flat screen TVs with DVD players, free WiFi Internet
Located: Near Times Square and Bryant Park
Subway: B, D, F, V 47 – 50 Streets – Rockefeller Center
Map: No. 23
Style: Contemporary design
What's special: Brought to you by André Balazs Properties, the same group that created benchmarks of cool, Chateau Marmont, The Mercer and The Standard. Hotel QT has Manhattan's only swim up bar ... in the lobby.

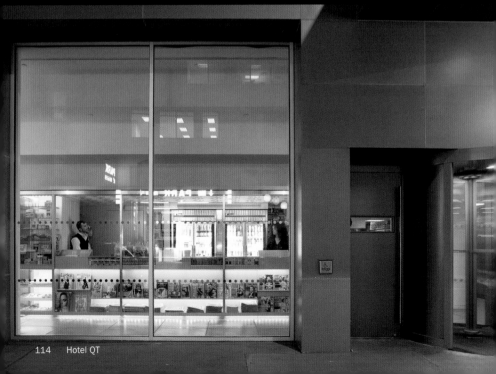

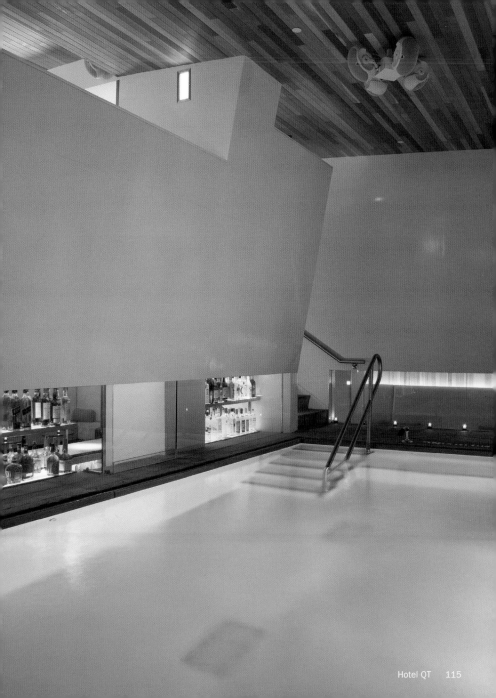

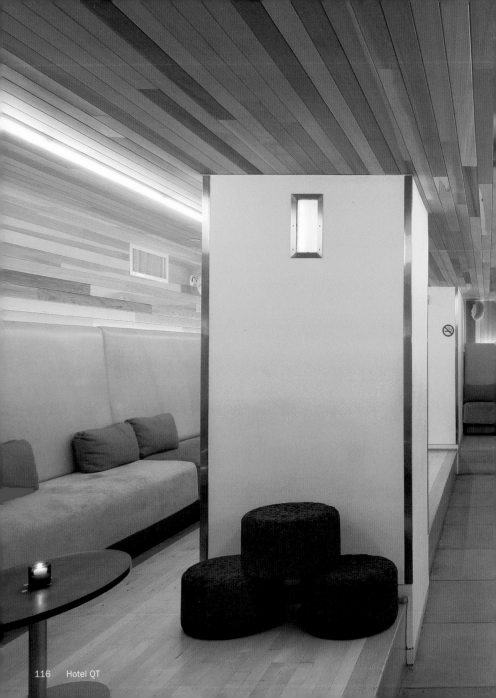

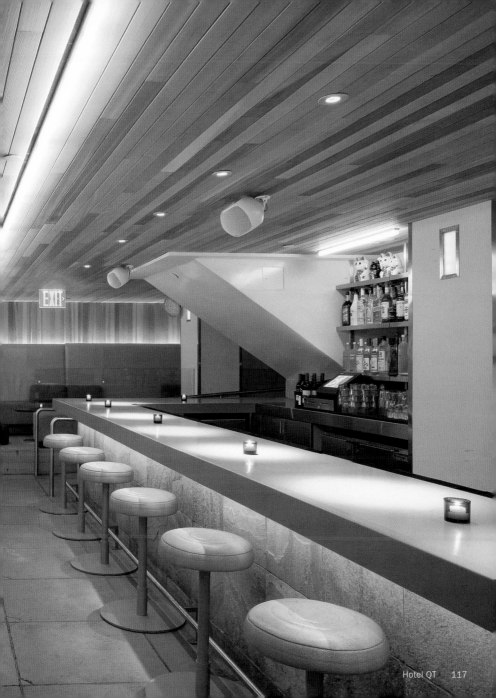

EXIT

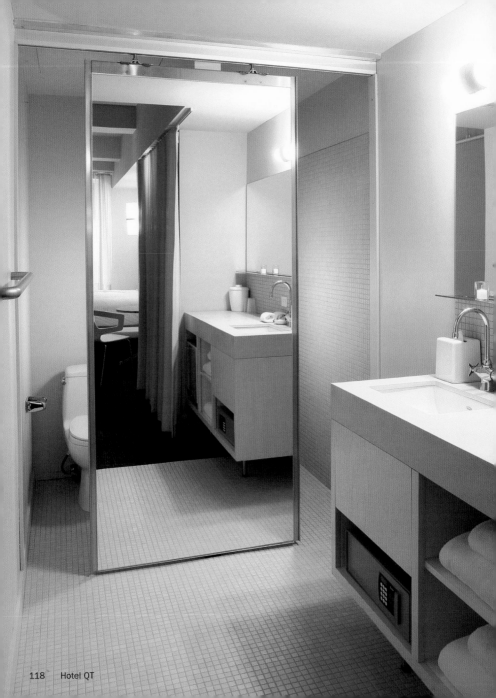

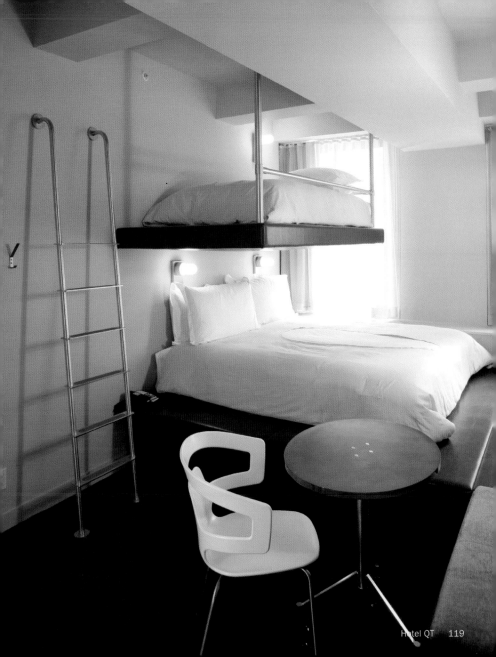

Hotel on Rivington

107 Rivington Street
New York, NY 10002
Lower East Side
Phone: +1 212 475 2600
Fax: +1 212 475 5959
www.hotelonrivington.com

Price category: $$$
Rooms: 110 rooms
Facilities: Restaurant THOR, meeting room, SURFACE penthouse for up to 125 people, in-room spa services, rental car service
Services: Internet access, flat screen TV
Located: Between Essex and Delancey Street
Subway: F Delancey Street; J, M, Z Essex Street
Map: No. 24
Style: Contemporary design
What's special: There are few, if any, hotels in New York in which you can gaze out at the skyline from one of the Japanese soaking tubs found in the larger suites. The hotel's floor to ceiling glass walls, and stylish design make this a constant presence on top ten hotel lists everywhere.

Cool Restaurants nearby:
wd~50

Cool Shops nearby:
Nakedeye

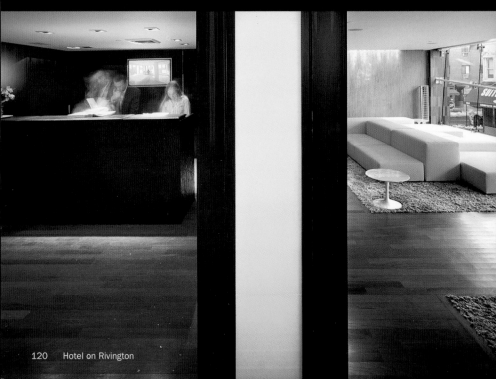

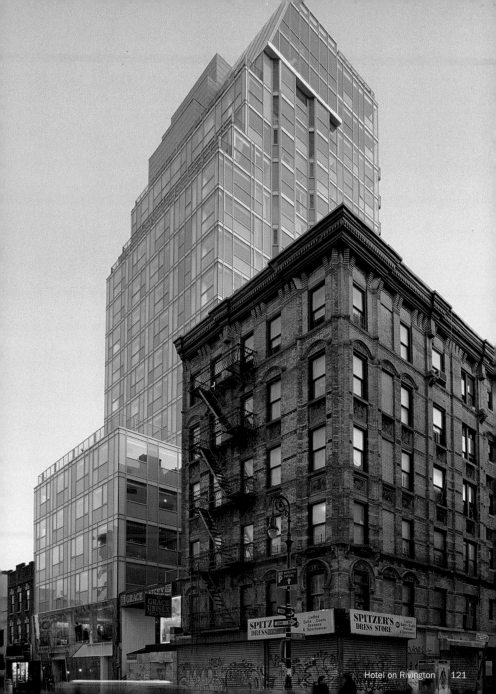

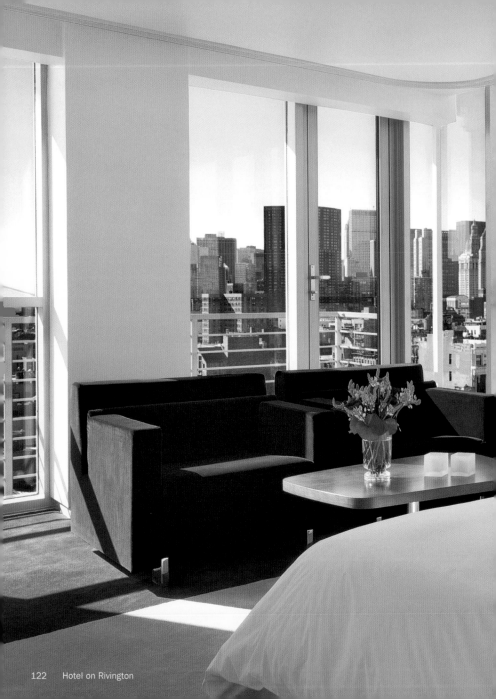

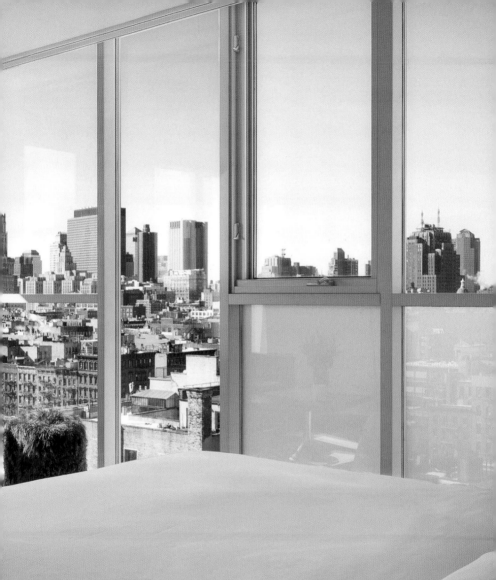

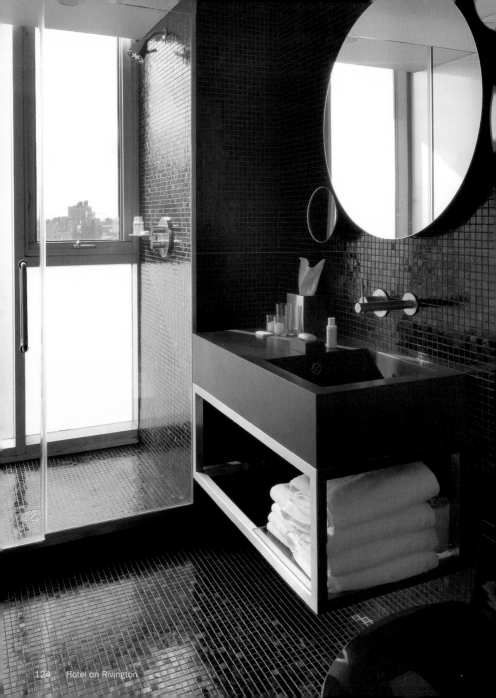

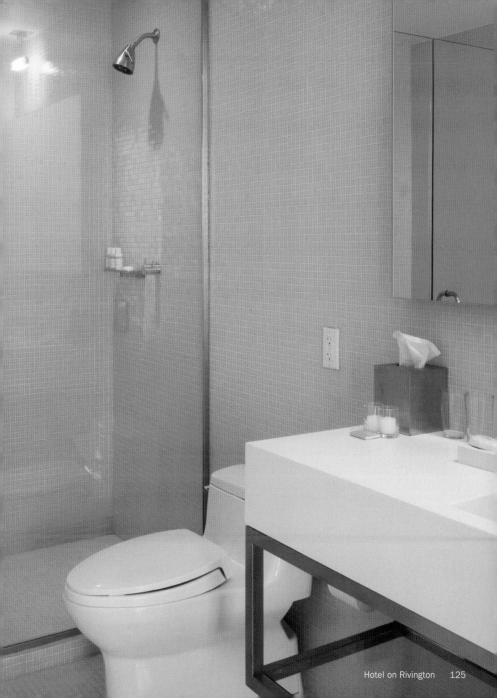

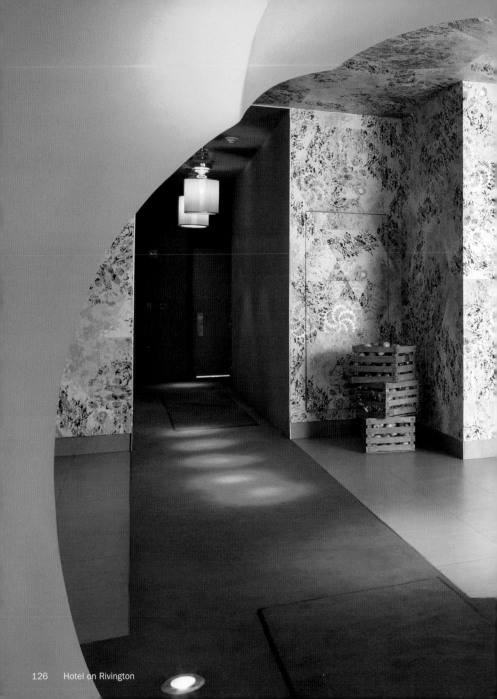

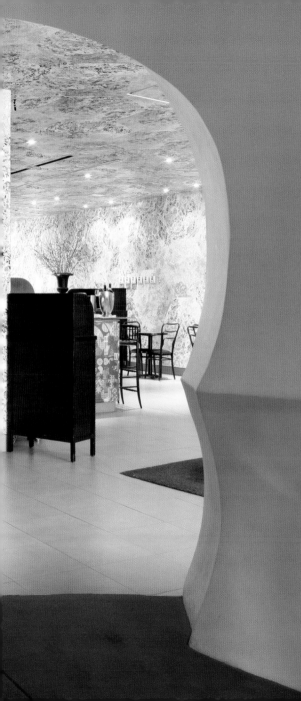

Hotel Roger Williams

131 Madison Avenue
New York, NY 10016
Midtown
Phone: +1 212 448 7000
Fax: +1 212 448 7007
www.hotelrogerwilliams.com

Cool Restaurants nearby:
Keens Steakhouse
Lever House Restaurant

Cool Shops nearby:
MoMa Design and Book Store

Price category: $$$
Rooms: 190 rooms
Facilities: Veranda 411 is 800 square feet in size and can accommodate up to 40 people for events
Services: Korres bath toiletries, mini-bars, irons with boards, in-room safes
Located: Situated near Grand Central Station and the Empire State Building
Subway: N, R, 6 33 Street
Map: No. 25
Style: Contemporary design
What's special: As if your mom and a modernist architect got together to create a hotel, Roger Williams is perhaps the most comfortably chic contemporary hotel in the city. The views of the Empire State Building are not to be missed.

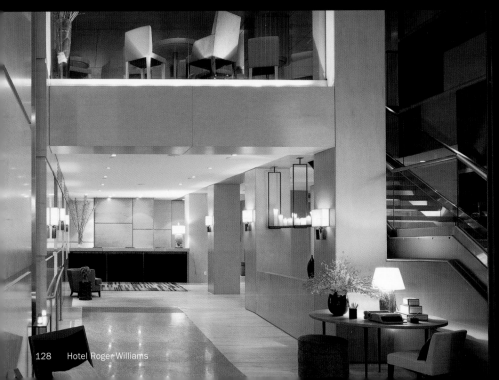

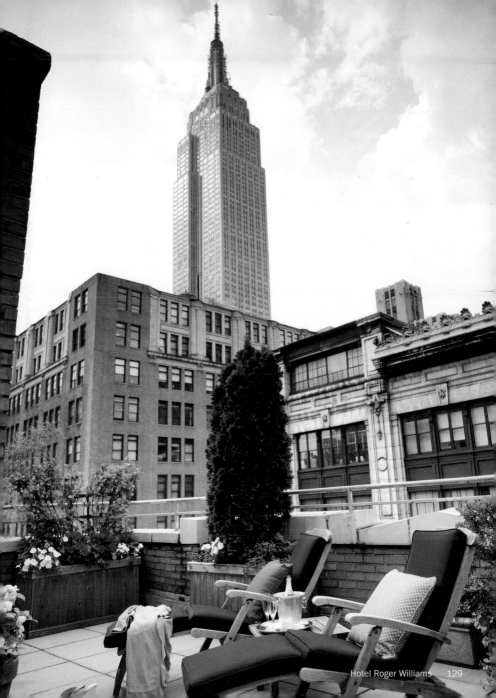

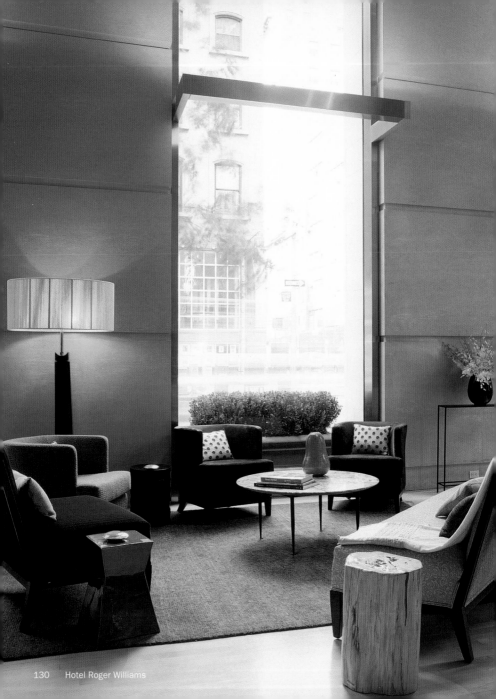

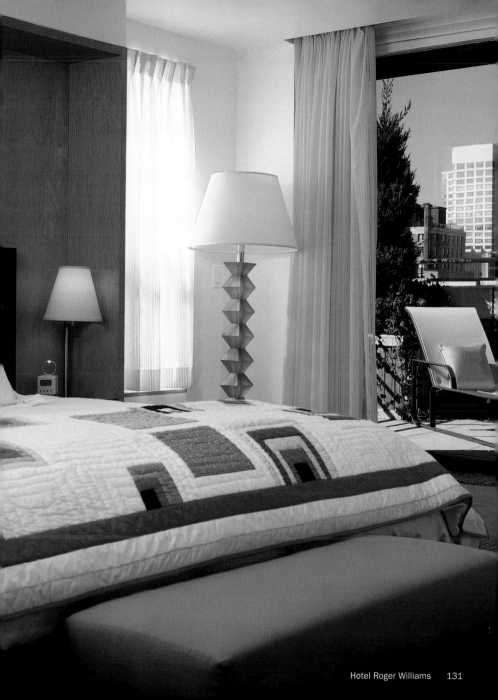

Sixty Thompson

60 Thompson Street
New York, NY 10012
SoHo
Phone: +1 877 431 0400
Fax: +1 212 246 3131
www.60thompson.com

Cool Restaurants nearby:
Kittichai
Peasant
Balthazar

Cool Shops nearby:
Prada
Dean & Deluca
Apple Store SoHo

Price category: $$$$
Rooms: 100 rooms
Facilities: Restaurant, bar, rooftop members lounge
Services: With a DVD player, CD stereo system and plush robes
Located: In the SoHo District
Subway: M, C, E Spring Street
Map: No. 26
Style: Contemporary design
What's special: Nestled in the heart of SoHo, Sixty Thompson is among the chicest addresses in Manhattan. The Thomas O'Brien designed hotel feels like a hip, forward thinking hotel should: edgy, understated but always attentive.

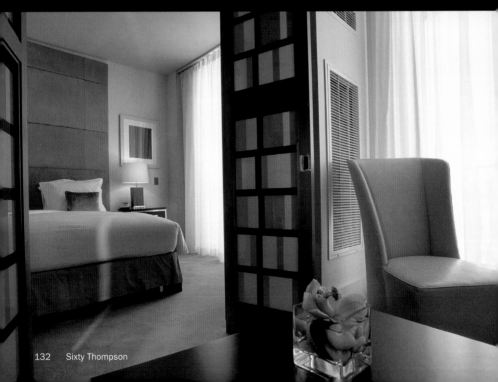

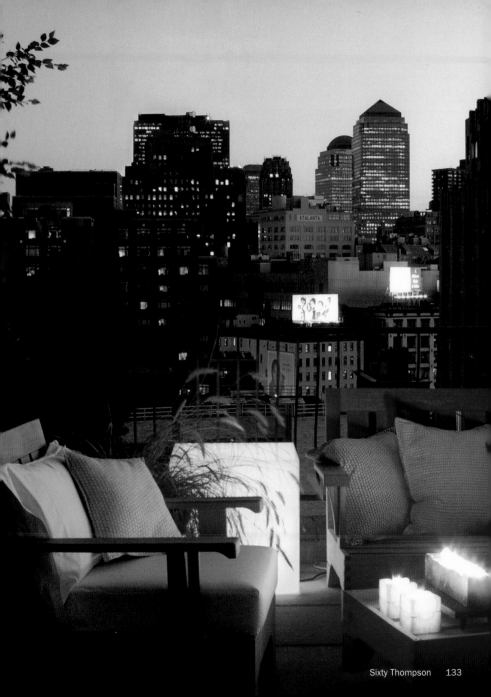

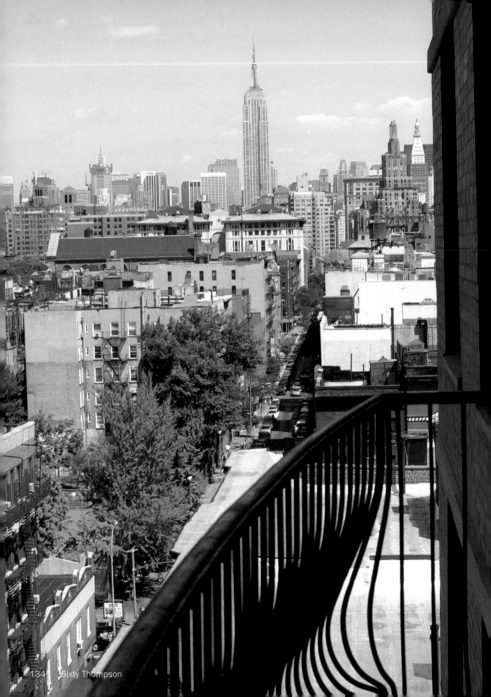

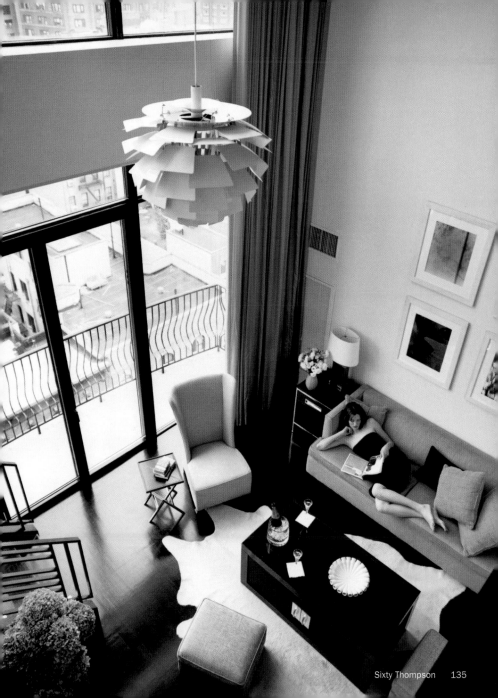

Time

224 West 49th Street
New York, NY 10019
Midtown / Times Square
Phone: +1 212 246 5252
Fax: +1 212 245 2305
www.thetimeny.com

Price category: $$
Rooms: 192 rooms
Facilities: Restaurant 7 Square with 90 seats, lounge, 24-hour fitness center
Services: Internet access
Located: On 49th Street between Eighth Avenue and Broadway
Subway: 1, C, E 50th Street; N, R, W 49th Street
Map: No. 27
Style: Contemporary design
What's special: The striking, boldly appointed rooms are scented and color coated according to mood and ambience. Cutting edge, contemporary design and innovative lodging concepts help to make the Time one of the best options for Times Square fun.

Cool Restaurants nearby:
Keens Steakhouse
Lever House Restaurant

Cool Shops nearby:
MoMa Design and Book Store

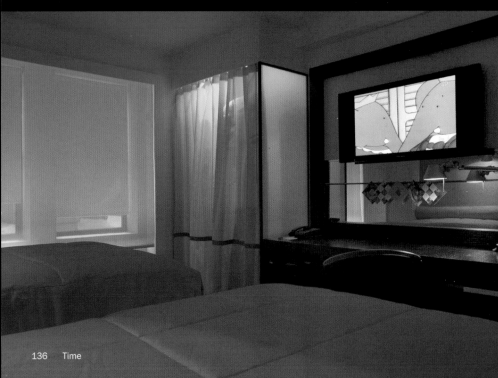

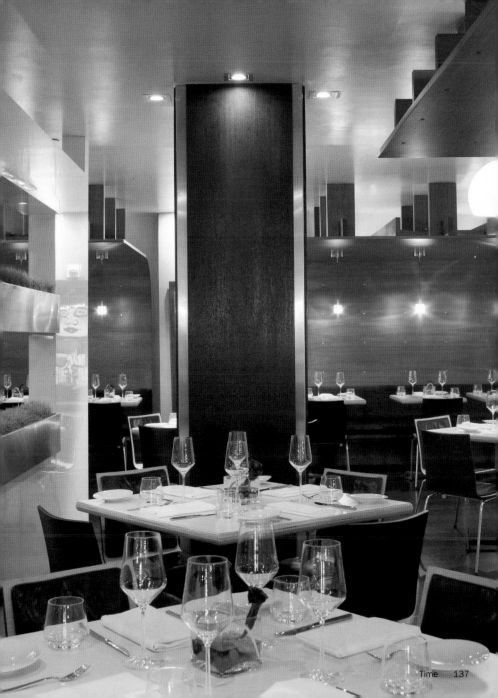

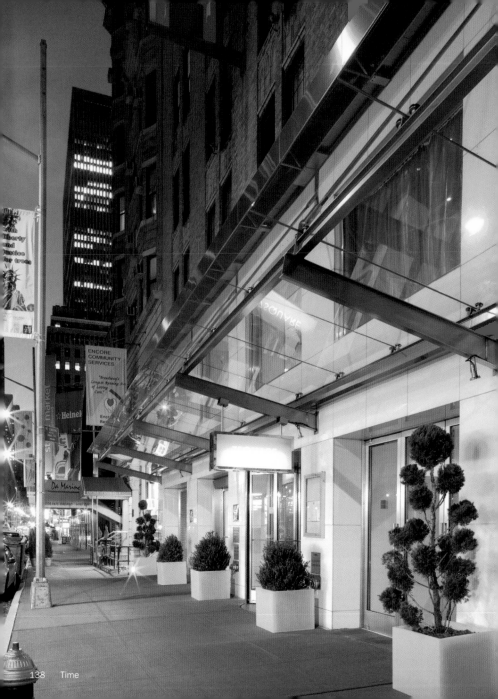

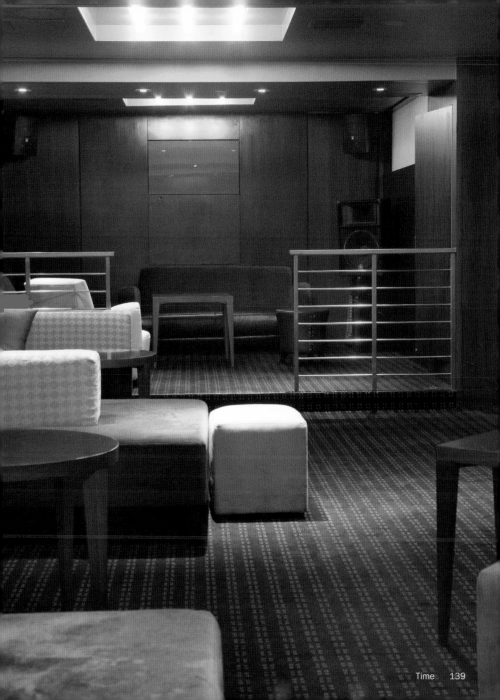

Tribeca Grand

2 Avenue of the Americas
New York, NY 10013
TriBeCa
Phone: +1 212 519 6600
Fax: +1 212 519 6700
www.tribecagrand.com

Cool Restaurants nearby:
66
Perry Street
Wallsée

Cool Shops nearby:
Moss
La Perla
Kirna Zabête
Jonathan Adler

Price category: $$$
Rooms: 203 luxurious guestrooms
Facilities: Gourmet-restaurant, bar, Church Lounge, 24-hour fitness center
Services: Pets are allowed, guestrooms with iPod & digital music system, coffee/tea/cocoa bar on each floor
Located: A short walk from the boutiques, restaurants and galleries of SoHo and TriBeCa
Subway: M, 1 Walker Street
Map: No. 28
Style: Contemporary design
What's special: During the TriBeCa film festival each spring, this hotel becomes the focal point for the media frenzy. The Church lounge offers some of the best people watching in the city.

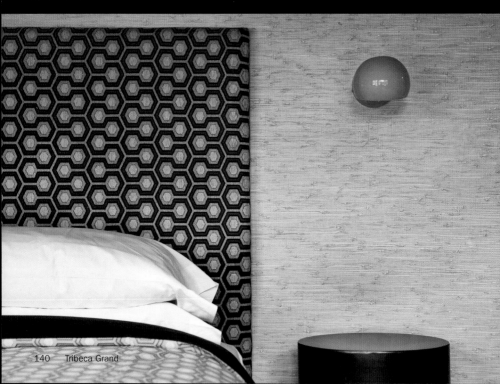

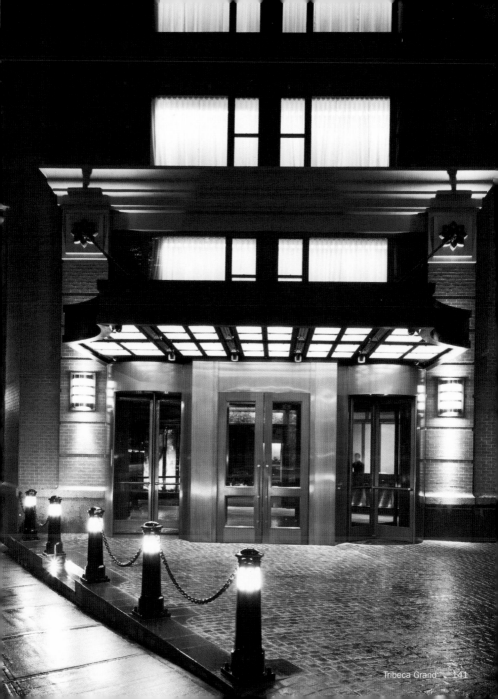

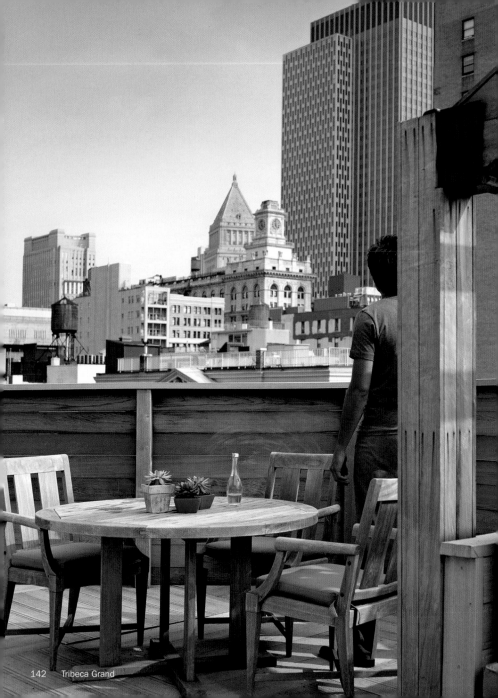

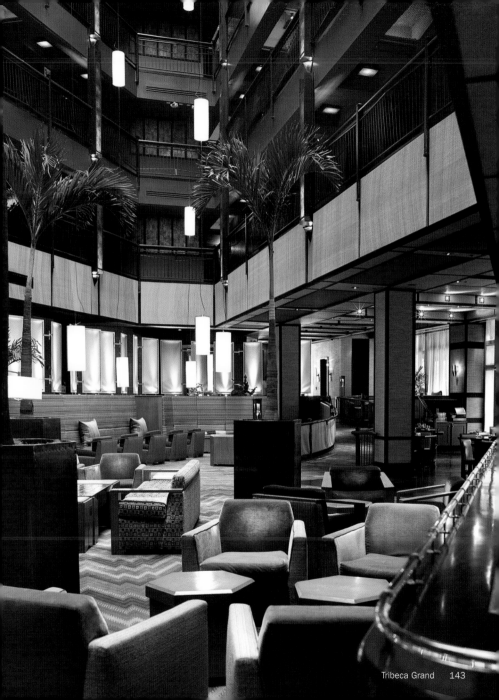

W New York – Times Square

1567 Broadway
New York, NY 10036
Midtown / Times Square
Phone: +1 212 930 7400
Fax: +1 212 930 7500
www.whotels.com

Price category: $$$
Rooms: 507 rooms and suites
Facilities: Restaurant Blue Fin, bars and nightclub, spa
Services: Non-smoking rooms, some pets allowed, mini-bar
Located: On Broadway, near Times Square and the Theater District
Subway: N, R, W 49 Street; 1 50 Street
Map: No. 29
Style: Contemporary design
What's special: As you have come to expect from W hotels around the world, the Times Square location is trendy, sleek and modern with built-in night life featuring three popular bars and the Whiskey nightclub. Rest assured, you will never get bored at the W New York.

Cool Restaurants nearby:
Keens Steakhouse

Cool Shops nearby:
MoMa Design and Book Store

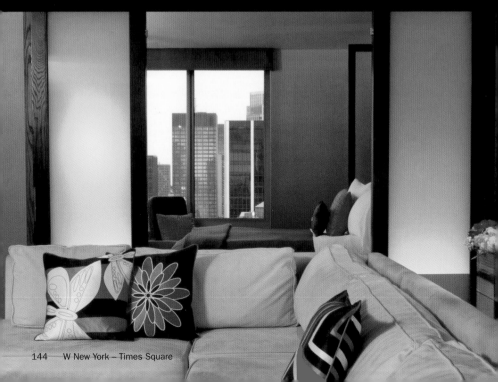

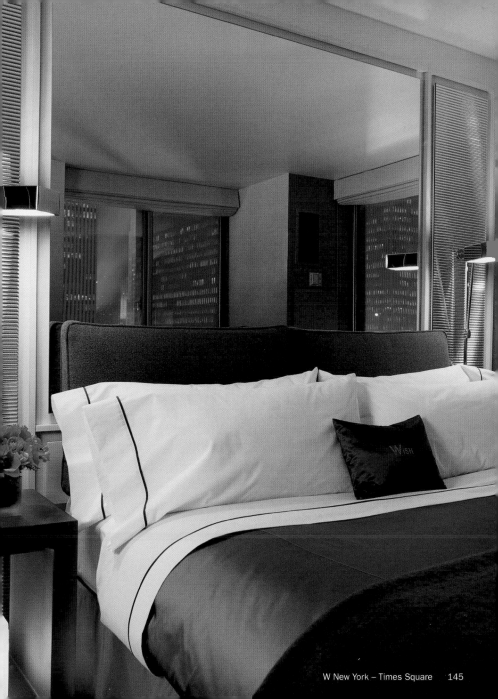

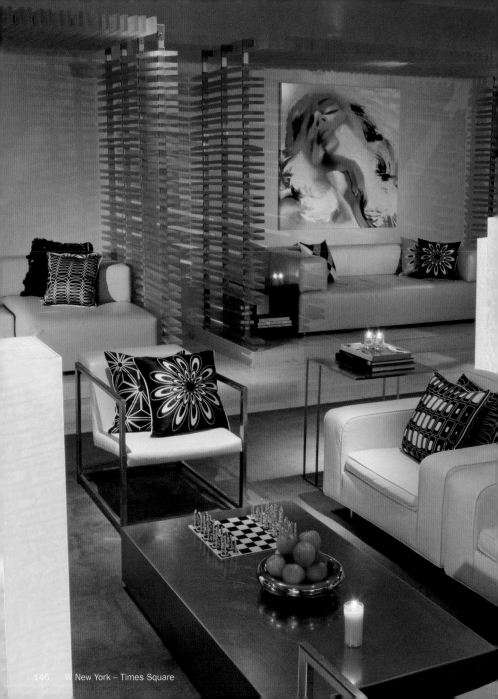

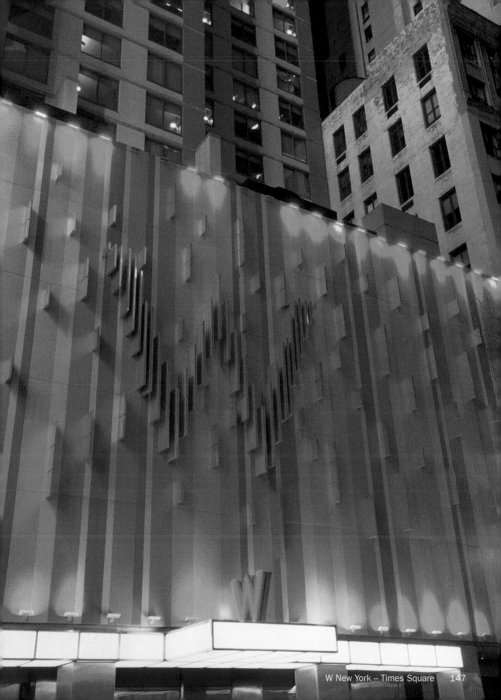

The Westin New York at Times Square

270 West 43rd Street
New York, NY 10036
Midtown
Phone: +1 212 201 2700
Fax: +1 212 201 2701
www.westinny.com

Price category: $$$
Rooms: 863 rooms and suites
Facilities: Restaurant, 24-hour in-room dining, Shula's Steak House, two bars, fitness center, spa
Services: 32" flat screen HD TV and iHome clock radio with iPod dock, Internet access
Located: In the Broadway District near Times Square, with 40 theatres within walking distance
Subway: A, C, E 42nd Street
Map: No. 30
Style: Contemporary design
What's special: Like a beacon of serenity in a sea of Times Square chaos, the Westin New York is a surprise from the moment you walk in the door. The bustle of the street outside gives way to an environment where service and attention are key.

Cool Restaurants nearby:
Keens Steakhouse

Cool Shops nearby:
MoMa Design and Book Store

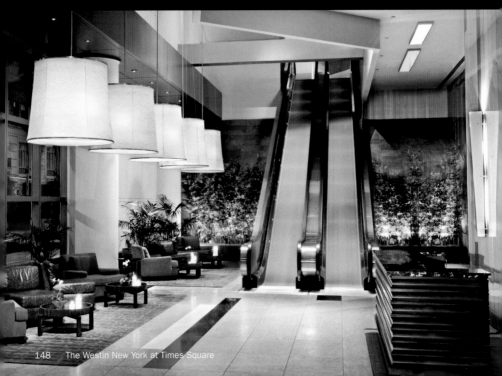

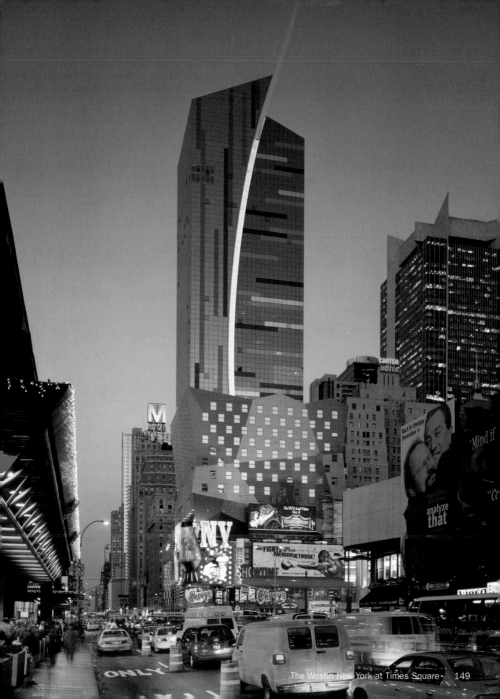

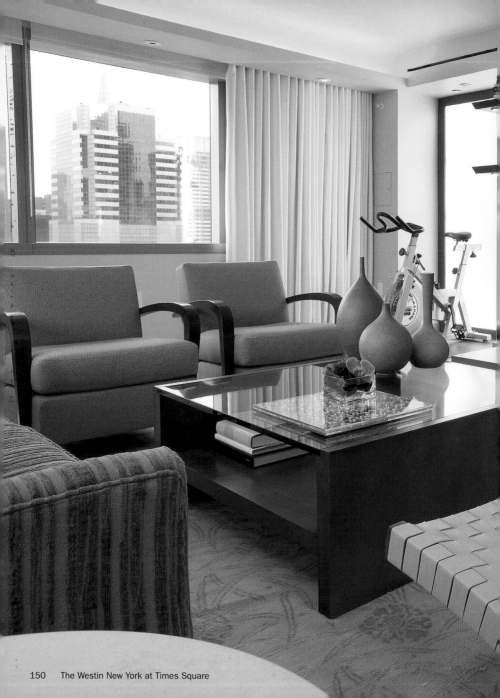

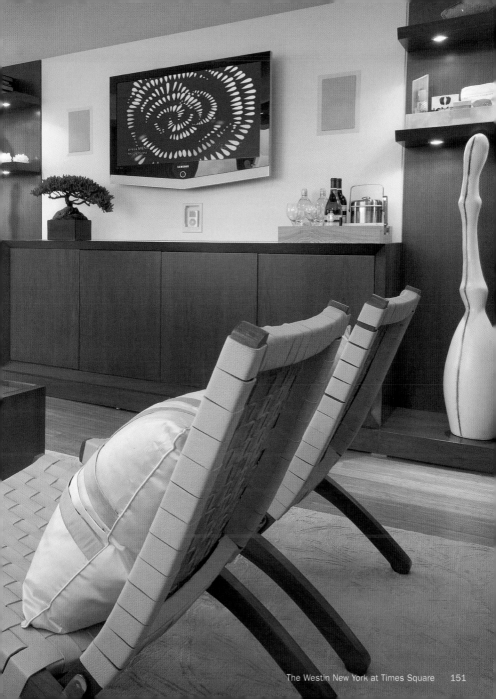

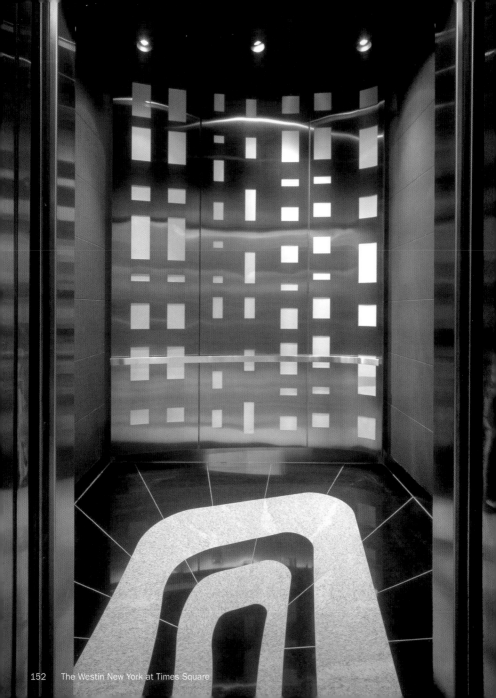

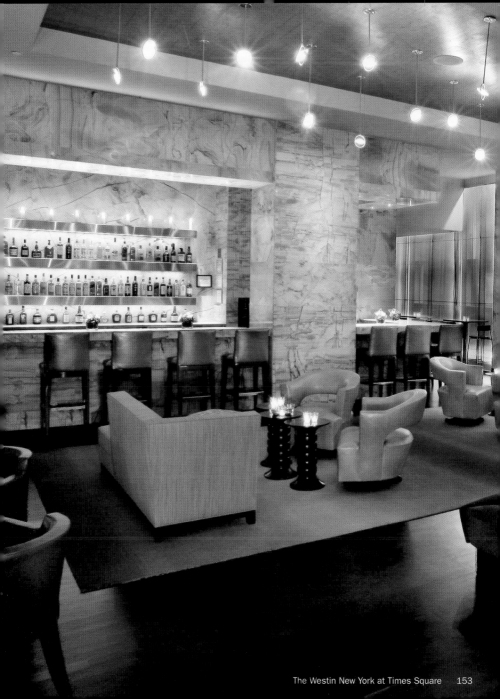

No.	Hotel	Page

NEW JERSEY

Holla

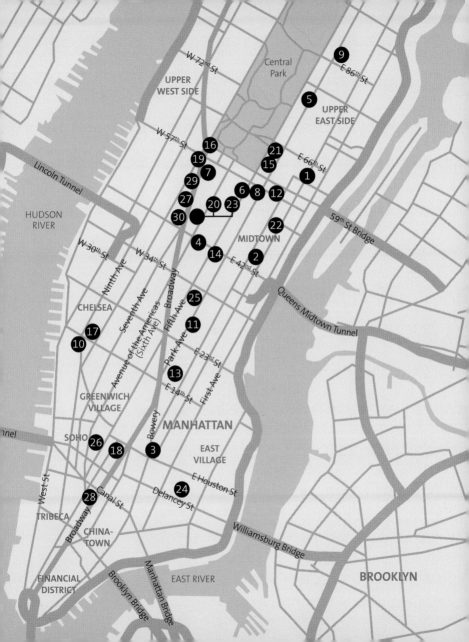

Cool Restaurants New York

- **66 |** 241 Church Street | TriBeCa | Phone: +1 212 925 0202 | www.jean-georges.com
- **Balthazar |** 80 Spring Street | SoHo | Phone: +1 212 965 1414 | www.balthazarny.com
- **Dévi |** 8 East 18th Street | Union Square | Phone: +1 212 691 1300 | www.devinyc.com
- **Four Seasons Restaurant |** 99 East 52nd Street | Midtown | Phone: +1 212 754 9494 | www.fourseasonsrestaurant.com
- **Freemans |** 191 Chrystie Street | Lower East Side | Phone: +1 212 420 0012 | www.freemansrestaurant.com
- **Indochine |** 430 Lafayette Street | NoHo | Phone: +1 212 505 5111
- **Jack's Luxury Oyster Bar |** 246 East 5th Street | East Village | Phone: +1 212 673 0338
- **Keens Steakhouse |** 72 West 36 Street | Midtown West | Phone: +1 212 947 3636 | www.keens.com
- **Kittichai |** 60 Thompson Street | SoHo | Phone: +1 212 219 2000 | www.kittichairestaurant.com
- **Lever House Restaurant |** 390 Park Avenue | Midtown East | Phone: +1 212 888 2700 | www.leverhouse.com
- **Lure Fishbar |** 142 Mercer Street | SoHo | Phone: +1 212 431 7676 | www.lurefishbar.com
- **Matsuri |** 369 West 16th Street | Chelsea | Phone: +1 212 243 6400 | www.themaritimehotel.com
- **Mercer Kitchen |** 99 Prince Street | SoHo | Phone: +1 212 966 5454 | www.jean-georges.com
- **Nobu Fifty Seven |** 40 West 57th Street | Midtown | Phone: +1 212 757 3000 | www.noburestaurants.com
- **Peasant |** 194 Elizabeth Street | SoHo | Phone: +1 212 965 9511 | www.peasantnyc.com
- **Perry Street |** 176 Perry Street | West Village | Phone: +1 212 352 1900 | www.jean-georges.com
- **Sant Ambroeus |** 1000 Madison Avenue | Upper East Side | Phone: +1 212 570 2211 | www.santambroeus.com
- **Spice Market |** 403 West 13th Street | Meatpacking District | Phone: +1 212 675 2322 | www.jean-georges.com
- **Wallsé |** 344 West 11th Street | West Village | Phone: +1 212 352 2300 | www.wallse.com
- **wd~50 |** 50 Clinton Street | Lower East Side | Phone: +1 212 477 2900 | www.wd-50.com

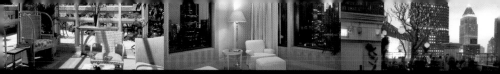

Cool Shops New York

- **ABC Carpet & Home** | 888 Broadway | Union Square | Phone: +1 212 473 3000 | www.abchome.com
- **A Détacher** | 262 Mott Street | SoHo | Phone: +1 212 625 3380
- **Alexander McQueen** | 417 West 14th Street | Chelsea | Phone: +1 212 645 1797 | www.alexandermcqueen.com
- **A.P.C.** | 131 Mercer Street | SoHo | Phone: +1 212 966 9685 | www.apc.fr
- **Apple Store SoHo** | 103 Prince Street | SoHo | Phone: +1 212 226 3126 | www.apple.com
- **BDDW** | 5 Crosby Street | SoHo | Phone: +1 212 625 1230 | www.bddw.com
- **Carlos Miele Flagship Store** | 408 West 14th Street | Meatpacking District | Phone: +1 646 336 6642 | www.carlosmiele.com.br
- **Dean & Deluca** | 560 Broadway | SoHo | Phone: +1 212 226 6800 | www.deandeluca.com
- **de Vera** | 1 Crosby Street | SoHo | Phone: +1 212 625 0838 | www.deveraobjects.com
- **Fragments** | 997 Madison Avenue | Upper East Side | Phone: +1 212 537 5000 | www.fragments.com
- **Jeffrey** | 449 West 14th Street | Chelsea | Phone: +1 212 206 1272
- **Jonathan Adler** | 47 Greene Street | SoHo | Phone: +1 212 941 8950 | www.jonathanadler.com
- **Kirna Zabête** | 96 Greene Street | SoHo | Phone: +1 212 941 9656 | www.kirnazabete.com
- **La Perla** | 93 Greene Street | SoHo | Phone: +1 212 219 0999 | www.laperla.com
- **Miya Shoji** | 109 West 17th Street | Chelsea | Phone: +1 212 243 6774 | www.miyashoji.com
- **MoMA Design and Book Store** | 11 West 53rd Street | Midtown | Phone: +1 212 708 9700 | www.momastore.org
- **Moss** | 146 Greene Street | SoHo | Phone: +1 212 204 7100 | www.mossonline.com
- **Nakedeye** | 192 Orchard Street | Lower East Side | Phone: +1 212 253 4935
- **Prada New York Epicenter** | 575 Broadway | SoHo | Phone: +1 212 334 8888 | www.prada.com
- **R by 45rpm** | 169 Mercer Street | SoHo | Phone: +1 917 237 0045 | www.rby45rpm.com
- **Rizzoli Bookstore** | 31 West 57th Street | Midtown | Phone: +1 212 759 2424 | www.rizzoliusa.com
- **The Conran Shop** | 407 East 59th Street | Midtown | Phone: +1 212 755 9079 | www.conran.com

COOL HOTELS CITY

Size: **15 x 19 cm**, 6 x 7 ¹/₂ in., 160 pp., **Flexicover**, c. 200 color photographs
Text: English / German / French / Spanish / Italian

Cool Hotels London
ISBN 978-3-8327-9206-0

Cool Hotels New York
ISBN 978-3-8327-9207-7

Cool Hotels Paris
ISBN 978-3-8327-9205-3

Related books by teNeues

Cool Restaurants New York
ISBN 978-3-8327-9130-8

Cool Shops New York
ISBN 978-3-8327-9021-9

New York City Highlights
ISBN 978-3-8327-9193-3

Size: **15 x 19 cm**, 6 x 7 ¹/₂ in. 160 pp., **Flexicover** c. 300 color photographs
Text: English / French / Spanish / Italian

New York and ⋮ guide
ISBN: 978-3-8327-9126-1

Size: **13 x 13 cm**, 5 x 5 in. (CD-sized format), 192 pp., **Flexicover**, c. 200 color photographs and plans.
Text: English / German / French / Spanish

Size: **14.6 x 22.5 cm**, 5 ³/₄ x 8 ³/₄ in., 136 pp., **Flexicover**, c. 130 color photographs,
Text: English / German / French / Spanish / Italian

Published in the COOL HOTELS Series

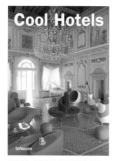

ISBN: 978-3-8327-9105-6

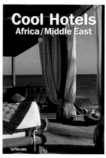

ISBN: 978-3-8327-9051-6

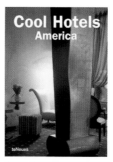

ISBN: 978-3-8238-4565-2

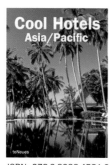

ISBN: 978-3-8238-4581-2

ISBN: 978-3-8327-9134-6

ISBN: 978-3-8327-9135-3

ISBN: 978-3-8238-4582-9

ISBN: 978-3-8327-9203-9

ISBN: 978-3-8327-9136-0

Size: **13.5 x 19 cm**, 5 ¼ x 7 ½ in., 400 pp., **Flexicover**, c. 400 color photographs,
Text: English / German / French / Spanish / Italian

Cool Restaurants

ISBN 978-3-8238-4586-7

ISBN 978-3-8238-4585-0

ISBN 978-3-8327-9146-9

ISBN 978-3-8327-9131-5

ISBN 978-3-8238-4587-4

ISBN 978-3-8327-9129-2

Other titles from the
COOL SERIES

Size: **14.6 x 22.5 cm**, $5^3/_4$ x $8^3/_4$ in., 136 pp.,
Flexicover, c. 130 color photographs,
Text: English / German / French / Spanish / Italian

Cool Shops

ISBN 978-3-8327-9073-8

ISBN 978-3-8327-9038-7

ISBN 978-3-8327-9022-6

ISBN 978-3-8327-9037-0